IMAGES of America
CENTRAL GEORGIA TEXTILE MILLS

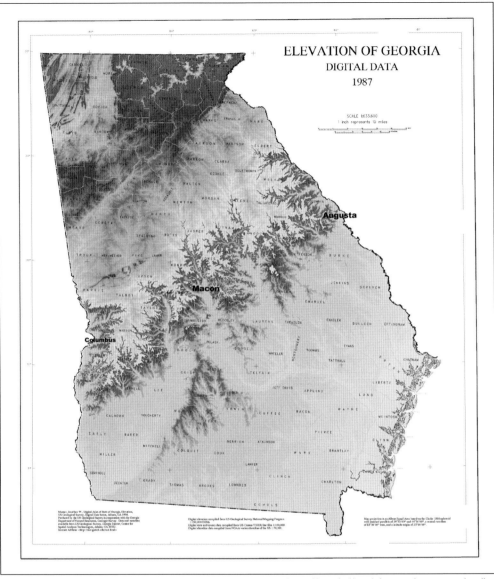

The fall line of Georgia is where the elevation falls from the rolling hills of the piedmont to the flat coastal region. The falling waters of the rivers on the fall line helped to power the textile mills of Central Georgia. This images shows the major cities on the fall line. (US Geological Survey.)

ON THE COVER: Two young workers at Bibb Mill No. 1 in Macon tend the textile machinery. Lewis Hine photographed child labor in the industries of America as a way to investigate and document working conditions. (Library of Congress; photograph by Lewis Hine.)

IMAGES
of America

CENTRAL GEORGIA TEXTILE MILLS

Billie Coleman

ARCADIA
PUBLISHING

Copyright © 2017 by Billie Coleman
ISBN 978-1-4671-2425-6

Published by Arcadia Publishing
Charleston, South Carolina

Printed in the United States of America

Library of Congress Control Number: 2016953533

For all general information, please contact Arcadia Publishing:
Telephone 843-853-2070
Fax 843-853-0044
E-mail sales@arcadiapublishing.com
For customer service and orders:
Toll-Free 1-888-313-2665

Visit us on the Internet at www.arcadiapublishing.com

*For my mother, Glenda Coleman, who encouraged my love
for reading and never got to see my accomplishments.*

Contents

Acknowledgments		6
Introduction		7
1.	Cotton Is King	9
2.	The Southern Textile Mill Worker	41
3.	Life in a Mill Village	75
4.	A Changing Industry and the Future	103
Bibliography		127

Acknowledgments

I would first like to thank the workers of the textile mills and their families, many of whose lives were always under the shadow of their employer. Second, I would like to thank photographer Lewis Hine; without his dedication to showing the plight of the child mill workers in the early 1900s, this book would not have been possible.

I am thankful for the help from Columbus State University Archives, who have gathered much information about the importance of Bibb City and the textile industry to Columbus, Georgia. I am thankful for the help from the Augusta Canal Authority, who have preserved the Augusta Canal and the history of the textile industry in Augusta, Georgia.

I would like to thank the former and current residents of Bibb Mill No. 1 Village, Bibb City, Payne City, and Porterdale who helped paint a picture of what it was like to grown up in a textile mill village. I would specifically like to thank some of the former residents of Bibb Mill No. 1 Village—Terry Webb, Elizabeth Lominick Bode, and Peggy Copeland—who have been an invaluable help in the creation of this book and have shared with me their fond memories of what it was like growing up in an idealistic community of a textile mill village of the mid-1900s, as well as relatives of former textile mill workers and former residents of the mill villages in Central Georgia.

Special thanks to my friends and family Christopher Coleman, Angela Bates, Jamie Mahan, Jim Branan, and Lonnie Davis, who have been a great help toward the creation of this book by accompanying me on research trips, editing, and providing historical insight. Thanks to my former professors from Middle Georgia State University Dr. Matthew Jennings and Dr. Stephen Taylor for inspiring me to write this book and providing valuable guidance. Lastly, I would like to thank John Cook for all his support and hard work. He has been there with me exploring, researching, and photographing the textile mills and villages, and his help has made this book possible.

INTRODUCTION

Cotton dominated the industrial and agricultural economy of Georgia since the state's founding in 1732. In the 1800s, the Industrial Revolution in America created a need for Southern cotton to be shipped to the textile mills in the North. Events like the Atlanta Cotton Exposition in 1895 introduced a new direction for the cotton industry in the South. Businessmen, investors, and politicians realized they needed to modernize and join the Industrial Revolution taking place across America. Originally, the cotton that was grown in the fields of the rural South was taken to local cotton warehouses, where it could be shipped by railroad and barges to the coast. From there, the cotton was shipped up North, where it would be turned into a variety of textiles at cotton mills. Then those manufactured goods would be shipped back to shops down South.

Community leaders across Central Georgia sought to bring textile mills to their towns. In Macon, a group of railroad owners came up with the idea to open their own mill so that the cotton grown in the nearby fields could be turned into textiles that could be sold all over the country and the world. These manufactured textile goods could be shipped across the South and the country via the railroads.

Central Georgia was a prime area for the establishment of textile mills because of the abundance of swiftly moving water that could be used to power the mill machinery. The geography along the fall line in Georgia, an area between Columbus and Augusta where the hills of the piedmont meet the upper coastal plain, creates a drop in elevation and fast-moving water. By harnessing this power source, mills across Central Georgia started an industrial revolution in rural Georgia that created a textile empire rivaling the mills in the North. Producing the textiles near where the cotton was grown cut out the middlemen, and the mills were able to create less expensive goods than others where the cotton had to be shipped in. Profits soared for the early cotton mills, and everyone wanted a piece of the action. Investors and community leaders raised funds to put up cotton mills all over Central Georgia. One of the larger textile companies was Bibb Manufacturing Company, but mills went up in small towns such as Thomaston, Dublin, Eastman, and Hawkinsville.

People from all over the rural areas of Central Georgia flocked to the mills for a chance at a steady, decent income and possible amenities. Workers were lured to textile mills by the opportunity for the whole family to work in the mills and have housing provided. This was an attractive offer for many widows, as the mother and her children could find employment in the mills. In the early days, mill work paid more than most could make sharecropping or in other employment, and with the added bonus of having housing provided, people could easily come to work at the mills with nothing and start a new life.

In the early 1900s, the labor force of the mills consisted of men, women, and children. Children as young as five years old were working at the mills for hours a day. Sometimes even younger children were used as lunch carriers or helpers.

By World War I, thousands of people were employed in mills across Central Georgia. Many of the textile mills changed focus to produce war products. As the war went on, many of the textile mill employees left to fight. The mills continued to grow after the war, and labor strikes and riots occurred in the 1920s and 1930s. By World War II, the major textile mills had surged in growth and were able to step up to the plate to produce products for the war effort such as tents, parachutes, and blankets. The textile mills in Central Georgia were some of the largest war matériel producers in the state.

During the Baby Boom era, the mills and mill communities became a great place to work and live. The children of mill employees were able to live an idealistic lifestyle in the community and enjoy the amenities provided by the textile mill company. As the rest of the country was desegregating, so were the textile mills. Before, mill workers would have been restricted to certain jobs because of their race, but as social equality progressed, jobs opened to all races.

As social development brought changes, the mills also had to deal with ever-changing technology. New technology was making the mills more automated, and the workforce was shrinking. The new technology was also expensive, and modernizing outdated textile mills was a costly venture that many companies could not afford. As the workforce changed, the textile mill companies started selling off houses and closing down community buildings and services. The homes were first offered to the mill workers, but many of them wanted to move to newer neighborhoods, so eventually the houses were sold to the public. The textile mill villages would never be the same.

As modernization progressed across America, the textile market became globalized. Many companies took advantage of new trade agreements and sought to move overseas for cheaper labor. Central Georgia was slowing losing its major industry of textile mills, and by the 1990s, most of the mills had been condensed or reduced to a very small workforce. The mills were no longer the wealthy powerhouses of the past, and many of them went bankrupt or were forced to sell out to competitors. By the 21st century, almost all of the textile mills in Central Georgia had been shut down; a few remain open today in limited operation.

As the mills closed down, the empty buildings became relics of the past. Some were demolished as parts of the buildings were falling into despair, while others saw potential in these large empty spaces. As an interest in lofts and refurbishing historical buildings into modern facilities grew, many of the mills across Central Georgia were slated to be turned into housing. Mysteriously, many of them caught fire due to arson or possible accidents. These large fires engulfed the massive buildings and only left behind small reminders of their importance to the community.

Other mills survived and have been used for lofts, restaurants, event venues, and many other purposes. The mill villages have seen a renewal of interest in their housing and community amenities. People are returning to the historical charm of the villages and are enjoying a sense of community once again.

There are many textile mills not covered in this book, but I hope I did justice to the legacy of all the textile mills and mill workers of Central Georgia.

One
COTTON IS KING

"Bring the cotton mills to the cotton field" was the rallying cry of Georgians in the late 1880s. Businessmen and community leaders across Central Georgia raised funds to build cotton mills for their citizens and take advantage of the profits in the growing textile industry.

Many of the early mills were located near the rivers in Augusta and Columbus. These mills were built to take advantage of the waterpower from the rivers, which not only powered the mills but also created electricity for the city. Other mills utilized various power sources but were still connected to railroads and river ports where they could ship the cotton into the mills and ship out the completed goods. Railroad owners were investors in mills such as the Bibb Manufacturing Company, which started in Macon.

In Central Georgia, textile mills were built to take advantage of the proximity of the nearby cotton fields. By bringing a mill to their community, investors were also creating jobs and exposing rural communities to industry. The economies of the rural communities were devastated by the Civil War and the loss of the agrarian culture. The textile mills were seen as a turning point for the Southern economy of Central Georgia. The textile mills produced a wide variety of goods, including cloth, yarn, rope, tire fabric, hosiery, towels, denim, linens, blankets, and drapery. By the early 1900s, most of the textile goods made in America were produced in the South, and Central Georgia had some of the largest textile mills. Once again, cotton had become king throughout Central Georgia, and the textile industry led the economy.

This chapter will travel through the mills of Central Georgia as they begin to change the landscape and workforce in the early 1900s. Around many of the textile mills, villages take shape as mill owners build housing and amenities for their workers. As Central Georgia begins to leave its agrarian past, a new kind of industry takes shape with the textile mills.

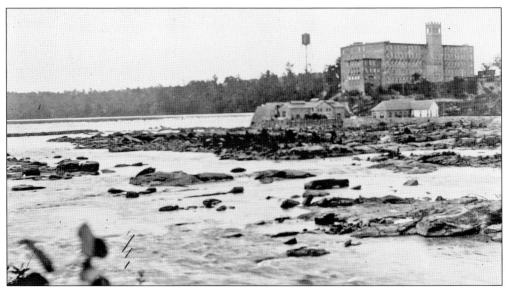

This view is across the river from the Bibb City Mill in Columbus. This is an early image of the electrical generator that helped power the textile mill. The falling waters of the Chattahoochee River on the Georgia-Alabama border created power for the mills. (Library of Congress.)

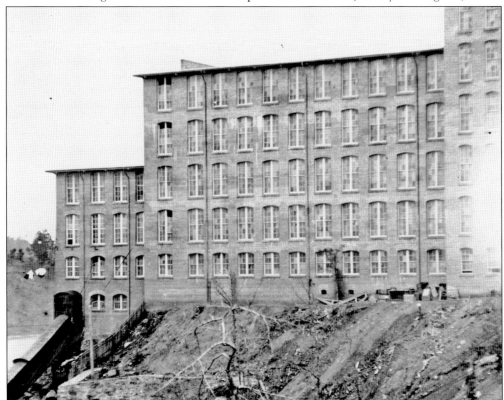

This view downriver from the power plant and textile mill on the Chattanooga River in Columbus looks up towards the Bibb City Mill, owned by Bibb Manufacturing Company. The fast-moving water was used to create electric power to run the mill equipment. (Library of Congress.)

Pictured is the front entrance of the Bibb City Mill in Columbus. This is where many of the employees entered the large mills to start their day. Note the clock to make sure the employees were on time for their shifts. (Library of Congress.)

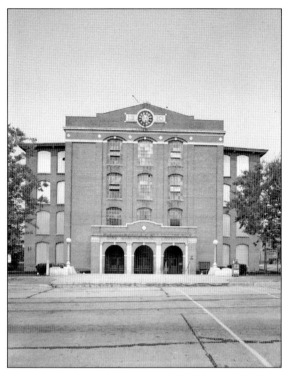

The Bibb City Mill in Columbus was the largest textile mill in the country. It produced textiles, carpet, and industrial products. This large textile mill stretched from the road to the river and supported the local economy. Bibb City grew up around the mill and was a home for the mill workers. (Library of Congress.)

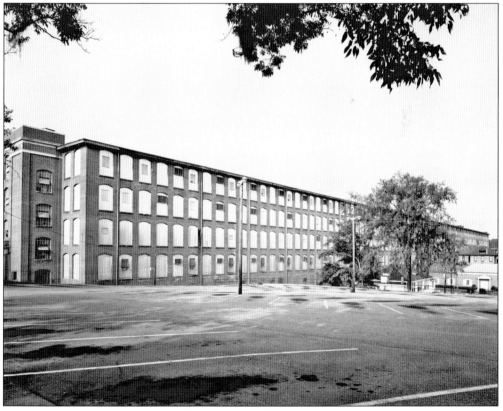

Pictured are the storage facility and warehouses for the Bibb City Mill in Columbus. It was the largest textile mill in the country during its prime, and there was a need for constant supplies and shipments. A textile mill was a complex facility that consisted of many layers that had to work smoothly together to create the final products. (Library of Congress.)

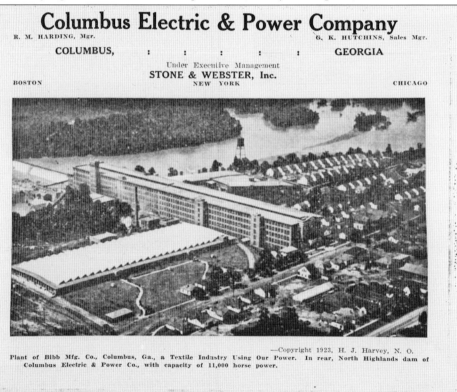

This aerial shot shows the Columbus Electric Company, which was part of the Bibb City Mill. The dam and power plant were originally built to power Bibb City Mill and are now owned by Georgia Power. The electricity generated by the plant now powers the city of Columbus. (Library of Congress.)

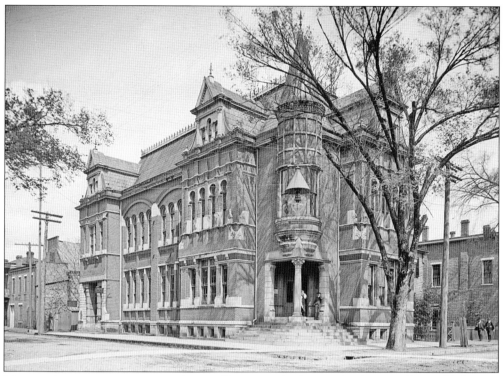

Many trades over cotton communities in Georgia took place at the Augusta Cotton Exchange, located right on the Savannah River in downtown Augusta, Georgia. The exchange opened in 1866 and was once the second largest cotton exchange in the world. Without the local cotton trade, the textile mills of Central Georgia would not have been possible. (Library of Congress.)

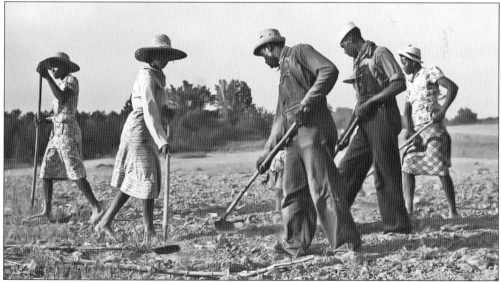

Workers in Central Georgia tend to a field of cotton. By locating near the cotton fields, the mills had easy access to cotton shipments. The cotton textile mills of Central Georgia would not have been possible without hard work from the field workers. (Library of Congress.)

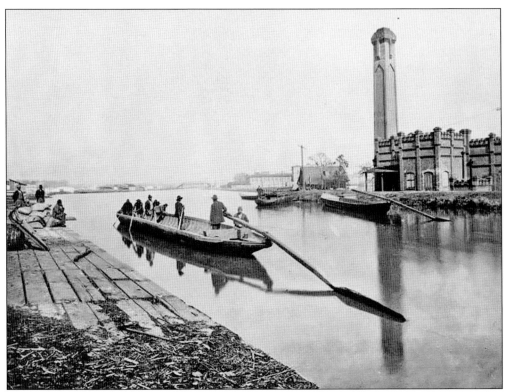

The Sibley Mill was located on the Augusta Canal. Petersburg boats like this one were used to haul goods up and down the canal to the Savannah River. These boats were made specifically for use on the canals and are still used today by the Augusta Canal Authority to take tourists on the Augusta Canal. (Library of Congress.)

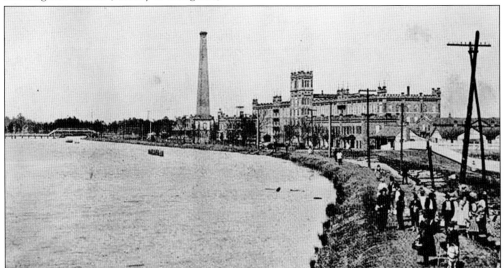

The Old Confederate Powder Works chimney, part of the Sibley Mill, overlooks the Augusta Canal. Augusta citizens and possibly mill workers walk along the edge of the canal for leisure. The canal was built for multiple purposes and provided the citizens of Augusta with clean water, power, and transportation. (Library of Congress.)

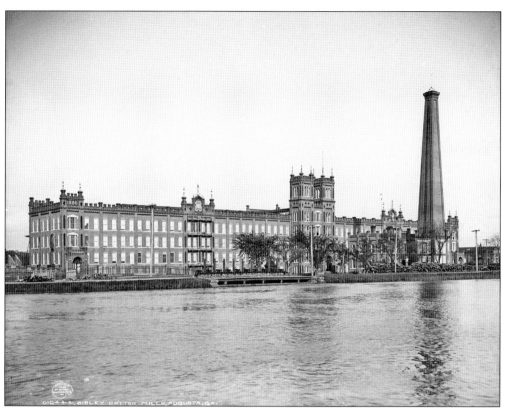

The Sibley Mill was built in 1880 on the site of the old Confederate Powder Works. The textile mill was designed by Jones S. Davis and has an ornate neo-Gothic exterior. The Confederate Powder Works was an important part of Civil War history in Augusta. (Library of Congress.)

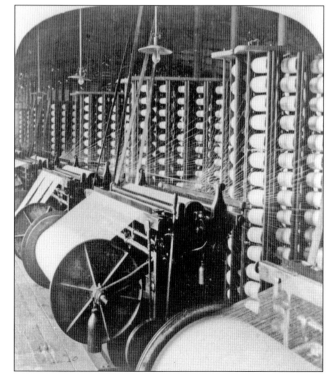

Warp yarns are laid on textile loom equipment inside one of Augusta's textile mills. The warping room machinery pulls thread from multiple spools to create a warp knit on the loom in the beginning stage of creating fabric. There are many different steps in the process of creating a final product. (Library of Congress.)

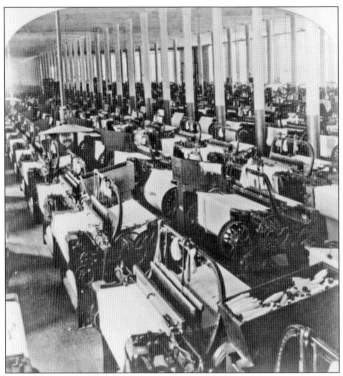

The weaving room is where the warp knit is woven with the weft yarns. This is a view inside an early cotton mill in Augusta. There are multiple pieces of equipment in the room so that the mill owners could produce as much textile as possible in the space available inside the mills. (Library of Congress.)

This look inside the Enterprise Mill shows the floor empty of employees. The Enterprise Mill, owned by the Enterprise Manufacturing Company, was located on the Augusta Canal in Augusta. The mills made many different textiles, from shirts to yarn. (Library of Congress.)

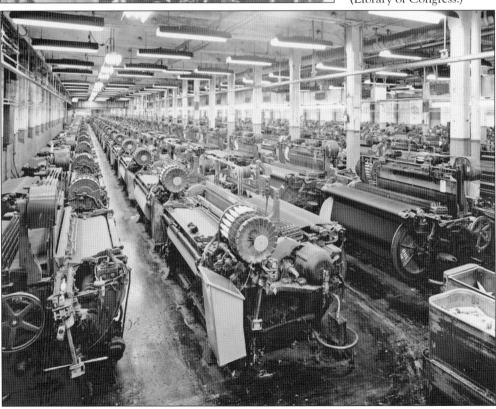

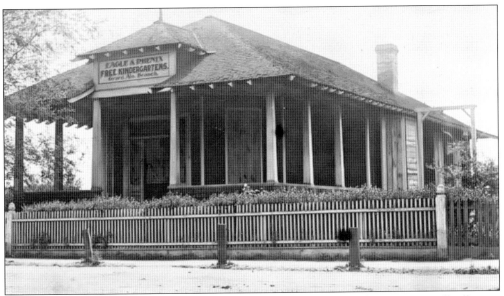

Many of the textile workers of the Eagle and Phenix Mills lived across the river in a mill village in what is now known as Phenix City. The mill established schools like this one to show its commitment to educating workers' families by establishing a free kindergarten. (Library of Congress.)

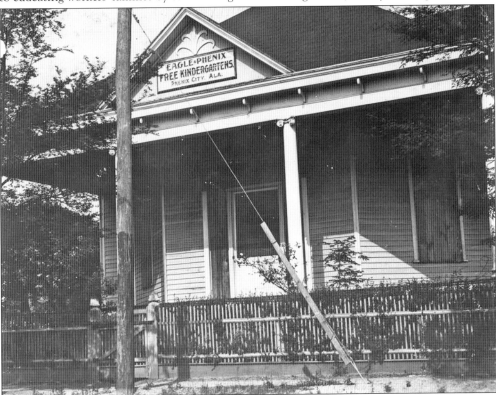

This school in Phenix City was established as part of the Eagle and Phenix Mills village. Unfortunately, in the early days, not many children attended, as they worked long hours in the textile mills each day. (Library of Congress.)

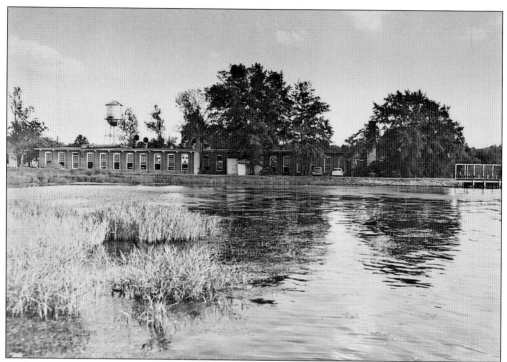

Taylor Mill, outside of Reynolds, is pictured during the mid-20th century. The mill was once known as Pottersville Mill and was a major employer in Reynolds. The mill was later sold to the Bibb Manufacturing Company, headquartered in nearby Macon. (Taylor County Historical Society.)

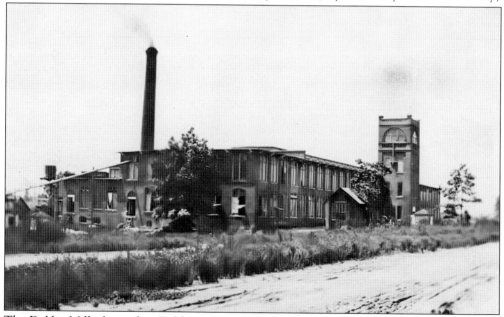

The Dublin Mills, located in Dublin, were in operation by 1902. The mill changed ownership many times and was not profitable in its short lifespan. It burned down in 1913. The bricks from the mill were later used to build an Italianate home on Bellevue Road in Dublin. (Laurens County Historical Society.)

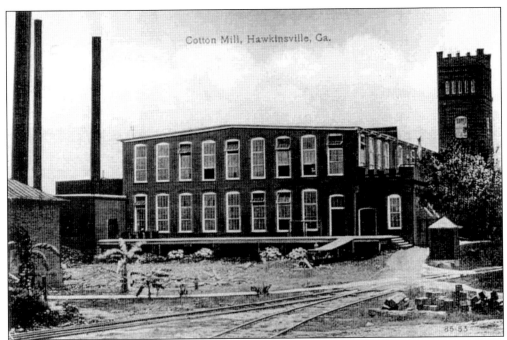

The Hawkinsville Cotton Mill was located on the Ocmulgee River in Hawkinsville. The mill was in a prime location, with nearby cotton farms and access on the Ocmulgee River to seaports. It was once a thriving local employer and provided housing for its employees. (Evelyn Williams.)

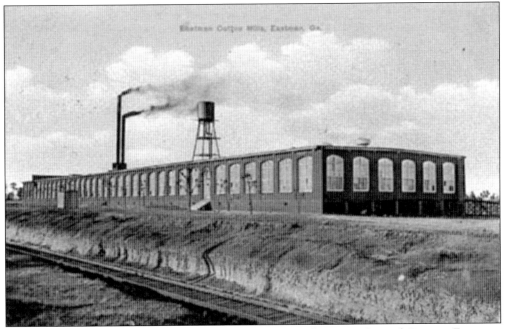

The Eastman Cotton Mills were located in Eastman, a small town in Central Georgia. For many years, the mills were a major employer in Dodge County, and the local economy once thrived because of the textile industry. This is a historic postcard from 1911. (Evelyn Williams.)

In the foreground is an archeological excavation that took place at Ocmulgee National Monument in the late 1930s. In the background is the smokestack of Bibb Mill No. 1 and some of the Bibb Mill No. 1 Village. The location of Bibb Mill No. 1 caused some disputes over the ownership of the funeral mound property with Ocmulgee National Monument. (Ocmulgee National Monument; photograph by Cokes Camera.)

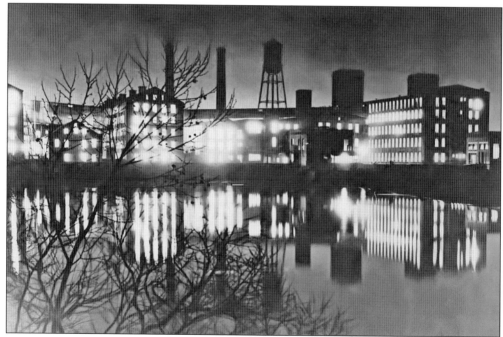

This interesting view shows the Eagle and Phenix Mills in Columbus reflected on the Chattahoochee River at night in the early 1900s. The Eagle and Phenix still shines out over Columbus and can be seen from across the river in what is now known as Phoenix City, Alabama. (Evelyn Williams.)

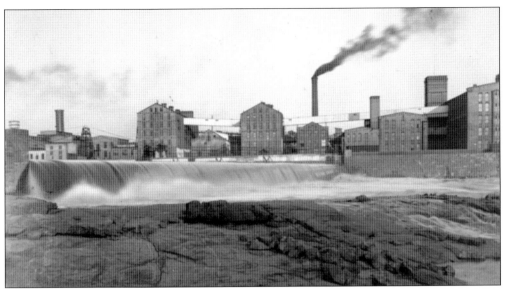

The Eagle and Phenix Mills are on the Chattahoochee River. The mills were located in downtown Columbus and were powered by hydroelectricity from the river. There were three textile mill buildings in operation, Mill No. 1, Mill No. 2, and Mill No. 3. (Library of Congress.)

The Willingham Cotton Mills were located in Macon, adjacent to the train tracks. The children in this photograph appear to be playing marbles outside the textile mill along the train tracks. They are possibly employees of the Willingham Mill. (Library of Congress; photograph by Lewis Hine.)

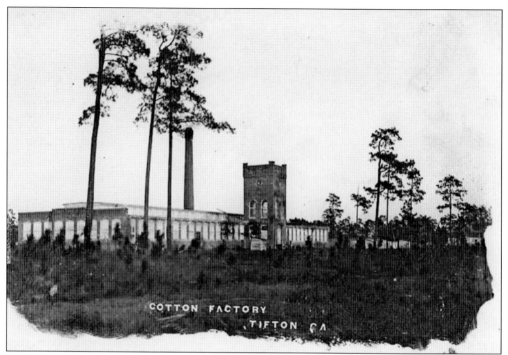

The Cotton Factory in Tifton was located in the southern portion of Central Georgia. It was not near a river, but it did have access to the railroads and was in a prime cotton-producing area. The mill supported a nearby mill village and employed many children and widows. (Evelyn Williams.)

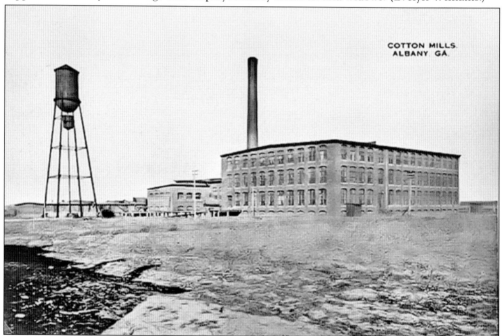

The Albany Cotton Mills were located on the Flint River in Albany. The mill produced textiles from the cotton that was grown in nearby fields. It was built in 1909 and was later renamed the Flint River Cotton Mill. This postcard is from around 1920. (Evelyn Williams.)

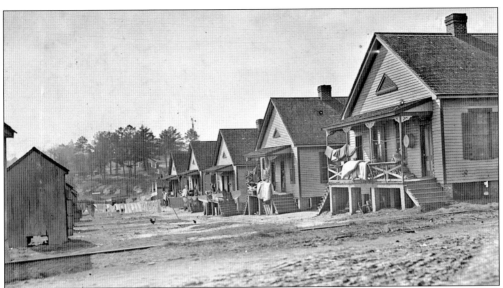

The Willingham Mill was located in Macon. This image provides a glimpse into the world of the Willingham mill village during the early days of the mill in 1909. These homes were duplexes that each housed two families. (Library of Congress; photograph by Lewis Hine.)

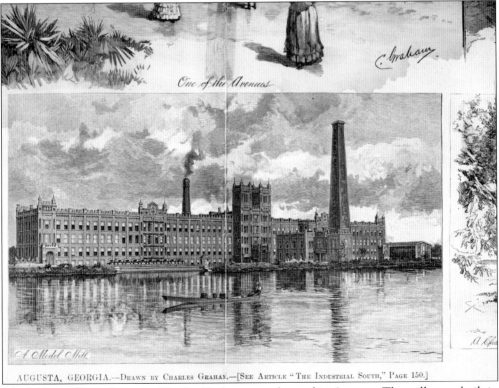

The Sibley Mills, as drawn by Charles Graham, were located in Augusta. The mills were built in the same location the Confederate Powder Works occupied during the Civil War to support the Confederate military. The Confederate Powder Works chimney is located in front of the mills. (Library of Congress.)

The Dartmouth Spinning Company would later be known as the Sutherland Mill. In this exterior view from 1968, the doors on the end of the second story that were used to take materials in and out of the mills are visible. The bell tower can also be seen. (Library of Congress.)

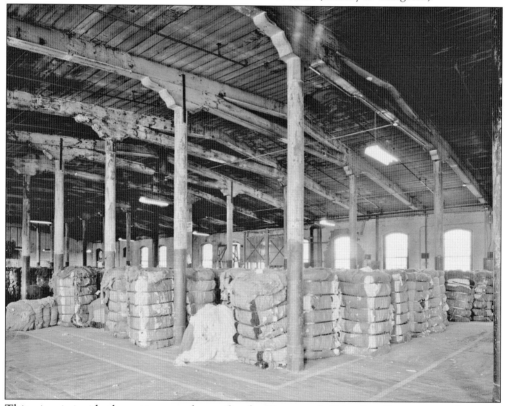

This view is inside the cotton warehouse for the Dartmouth Spinning Company in Augusta. The first part of the textile production process is acquiring cotton. The textile mills of Central Georgia could easily acquire cotton from nearby fields. The mills would weigh and sort the cotton before textile production. (Library of Congress.)

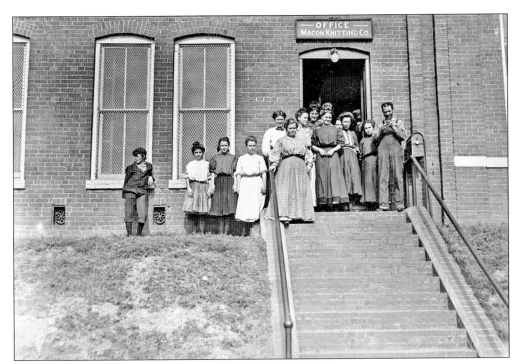

The Macon Knitting Company was located in Macon. This textile mill produced hosiery for women, most likely from cotton and other fibers. Hosiery was a necessary part of a woman's wardrobe in the early 1900s. (Library of Congress; photograph by Lewis Hine.)

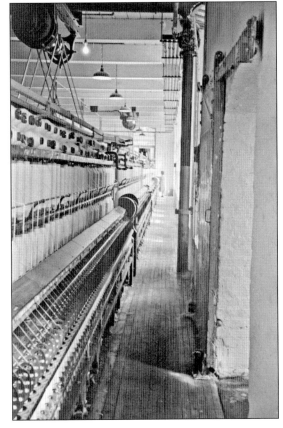

In this look inside a mill in Central Georgia, the machinery is all quiet, but usually the inside of the mills was a very active environment with fast-moving machinery and cotton fibers. (Library of Congress.)

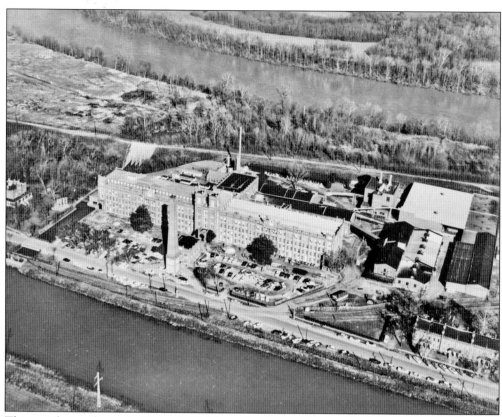

This aerial view shows the Sibley Mill. The mill is located on the Augusta Canal and is situated on a narrow piece of land that separates the canal from the Savannah River behind the mill. The Augusta Canal was created so that Augusta could have a controlled waterway for power, transportation, and water. (Library of Congress.)

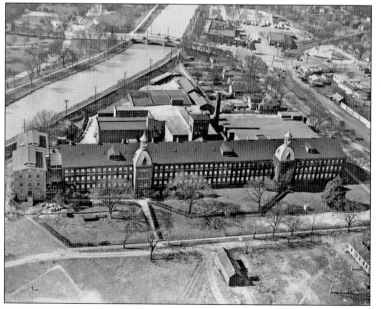

The Enterprise Mill is seen in an aerial photograph of the city of Augusta. The view shows the mill's location on the Augusta Canal. The Enterprise Mill used the canal for hydropower to run its machinery. (Library of Congress.)

Part of the interworking of the Enterprise Mill is seen here as it appeared in 1977. This part of the machinery helped to power the large textile looms inside the mills. The main source of electric power for the mills was the Augusta Canal. (Library of Congress.)

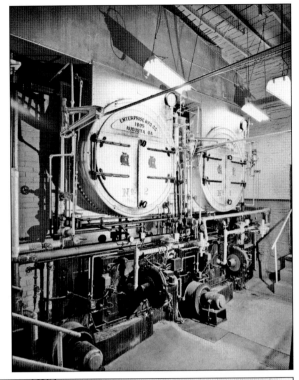

This advertisement is from the Enterprise Manufacturing Company in Augusta. The textile mill manufactured shirts, bedsheets, yarns, and drill fabric. Drill fabric is a strong durable cotton fabric with a strong diagonal-bias weave. It is often used in khakis and to create uniforms. (Library of Congress.)

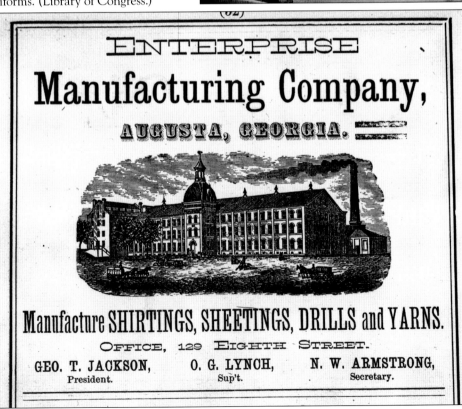

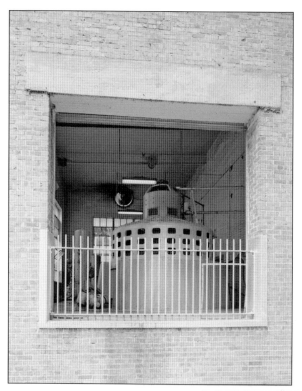

This generator powered the Enterprise Mill in Augusta. Power equipment was a very important part of the textile mills: without the hydropower of the rivers, the cost of operating a mill would have been tremendous. By creating their own power source, the mills were able to keep costs down and remain efficient. (Library of Congress.)

This bell is part of the Sibley Mill. Many of the mills in Augusta had bell towers to notify the neighborhood and the workers of the time of day and to notify workers during special circumstances. (Library of Congress.)

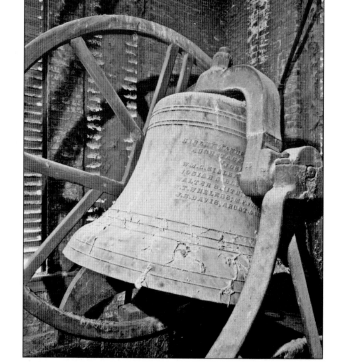

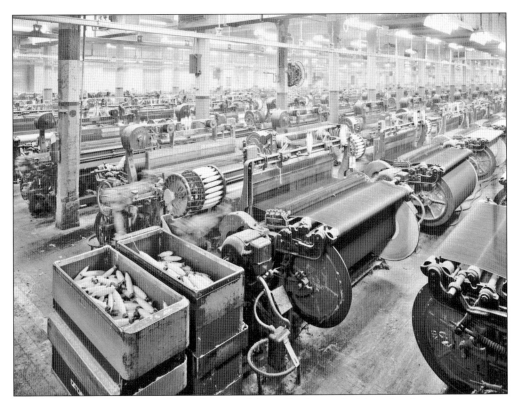

As the years went by, the textile machinery of the mills changed with technology. In this image, many weaving machines still have to have the individual spindles replaced, but they could make multiple types of fabric at the same time. (Library of Congress.)

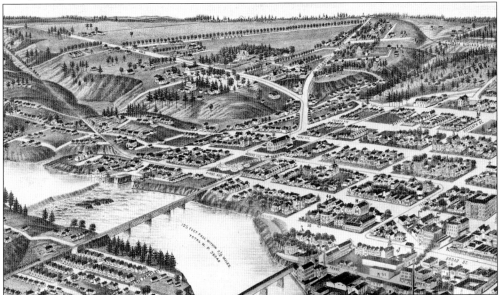

This map depicts Columbus in the early 1900s. Many of the textile mill properties on the Chattahoochee River can be seen. In the bottom portion, the mill village for the Eagle and Phenix Mills is shown on the Alabama side of the river. (Library of Congress.)

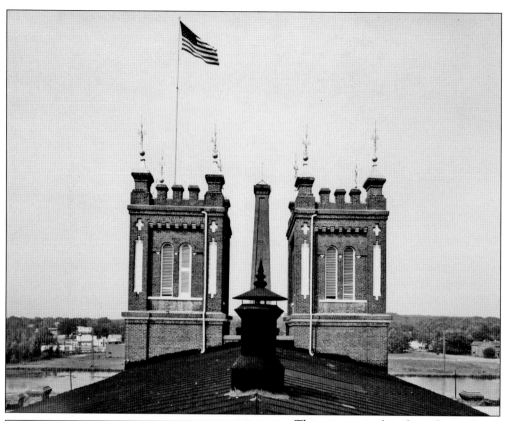

This view was taken from the roof of Sibley Mill. From this angle, the back of the Confederate Powder Works chimney can be seen. The Augusta Canal is also visible, as well as mill housing for the Sibley Mill on the other side of the canal. (Library of Congress.)

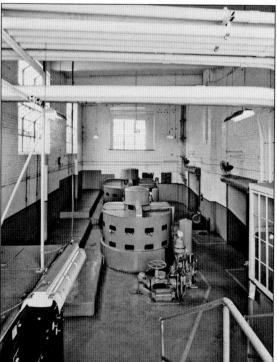

This is part of the generating equipment of the Sibley Mill on the Augusta Canal. The hydroelectric power is generated by the waters of the canal, which is fed by the Savannah River. Hydroelectricity did not just power the mills, but also the city of Augusta. (Library of Congress.)

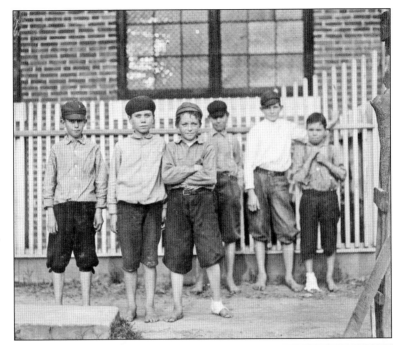

These young boys are textile workers for the Massey Hosiery Mills in Columbus. Note that all the boys are barefooted, and some of them have bandaged feet. Child laborers in the textile mills of Central Georgia in the early 1900s were living in terrible conditions. (Library of Congress; photograph by Lewis Hine.)

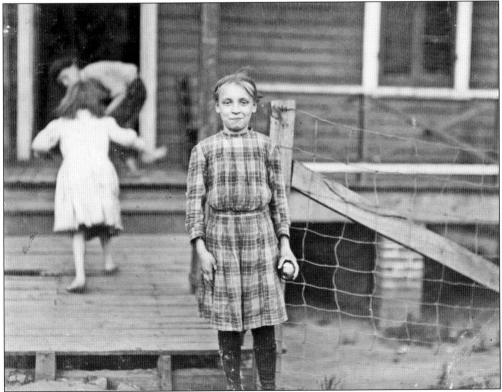

The young girl in this 1913 photograph in front of a mill house in Columbus is Minnie Lee Partain, who was a regular helper at the mills. The children are playing on the steps of the house and across the raised walkway from the home. (Library of Congress; photograph by Lewis Hine.)

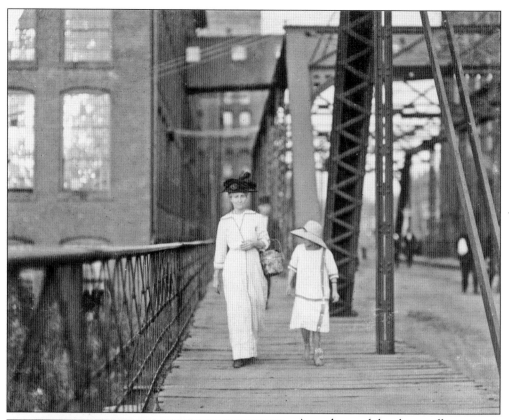

A mother and daughter walk across the raised platform on the Chattahoochee River Bridge as they make their way home from the Muscogee mills. The little girl is wearing a large sun hat and has bare feet, while the mother carries a basket. The child was considered a helper at the mills and possibly not an official employee. (Library of Congress; photograph by Lewis Hine.)

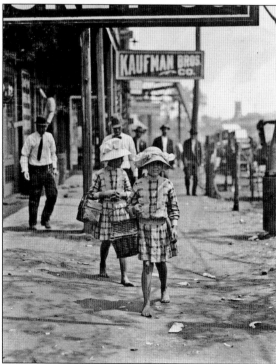

Two little dinner toters in matching outfits are caught in a snapshot on the street in 1913. These girls would walk from their homes in their little bonnets with bare feet on the dirty streets of downtown Columbus to deliver meals to their family members working in the mill. (Library of Congress; photograph by Lewis Hine.)

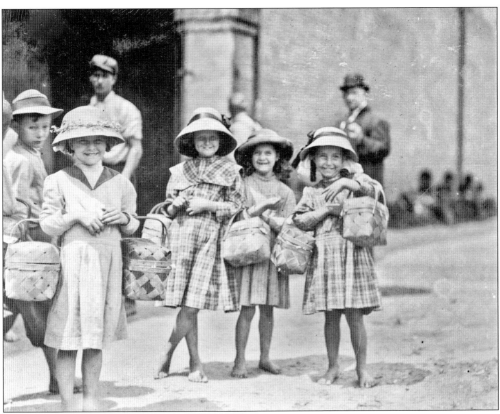

These little girls, pictured in 1913 in Columbus, were called dinner toters. These children helped support the textile workers by bringing dinner from home to the mill. Most likely they are bringing dinner to family members. (Library of Congress; photograph by Lewis Hine.)

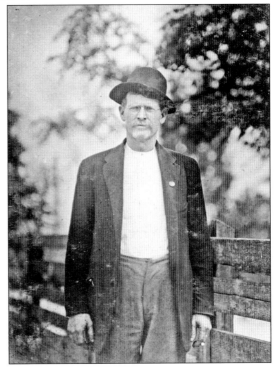

A life of working in the textile mills of Central Georgia for 40 years was a rough one. Frank Barnes, in this 1913 photograph, had been working in the textile mills since he was four years old. He still was not making enough wages to keep from putting his kids to work in the mills to support the family. (Library of Congress; photograph by Lewis Hine.)

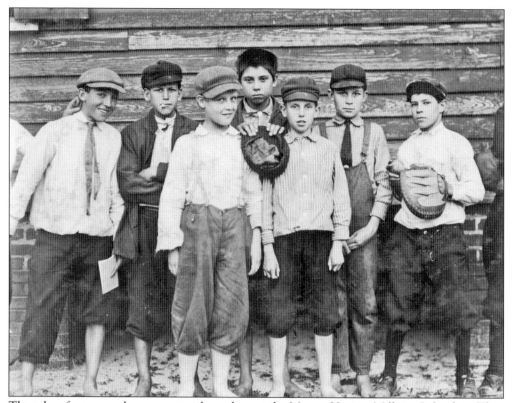

These barefoot young boys were textile workers at the Massey Hosiery Mills in Columbus. They are taking a supper break and playing baseball between their day shift and night shift. At this mill, it was common for the children to work the night shift. (Library of Congress; photograph by Lewis Hine.)

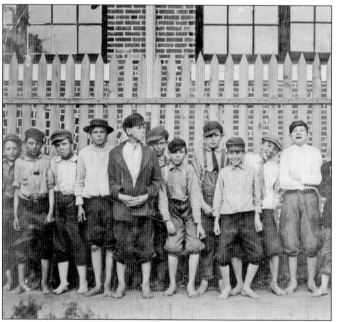

A group of young textile mill workers in Columbus cuts up for this snapshot. These younger workers of the Massey Hosiery Mills are on break to get supper after their day shift and before they go back to work the night shift. Many times, they worked before and after school. (Library of Congress; photograph by Lewis Hine.)

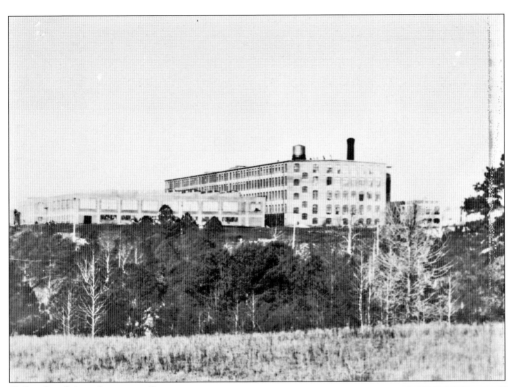

Columbus Manufacturing Company, pictured in 1919, was founded by W.C. Bradley, an owner of the Eagle and Phenix Mill in Columbus. Bradley owned two of the largest textile companies in the South and was an entrepreneur who invested in multiple businesses in Columbus and on the global market. (Library of Congress.)

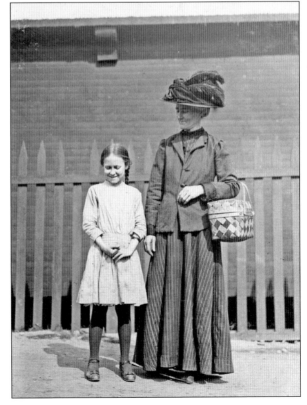

This young girl is a helper for her mother at the Muscogee Mill in Columbus. She totes dinner and helps her mother with mill work. At the textile mills in Central Georgia in 1913, it was common to have many younger helpers. (Library of Congress; photograph by Lewis Hine.)

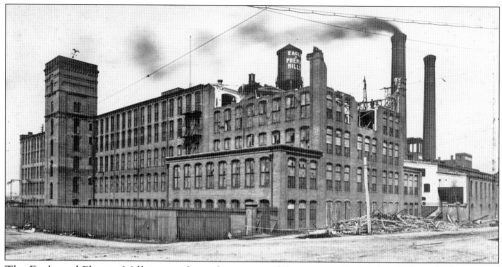

The Eagle and Phenix Mill is seen from the streets of downtown Columbus. Though the textile mills of Central Georgia produced fine products, the mills themselves were a dirty and harsh business for the environment. During the early 1900s, the industrial South was rarely regulated, and mills were operated to be the most cost effective. (Library of Congress.)

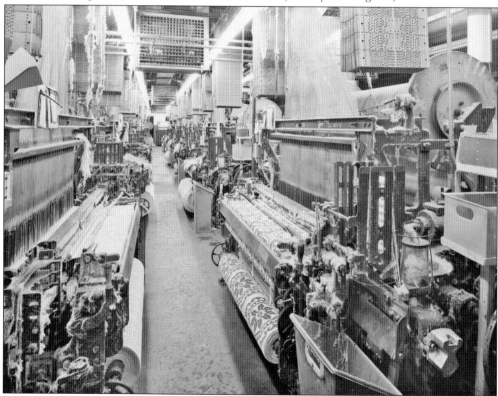

Inside this Central Georgia mill, workers are producing a floral textile. The complex inner workings of what it takes to create a designed fabric can be seen. Thousands of different threads come together to create an intricate design that was made possible by the textile machinery. (Library of Congress.)

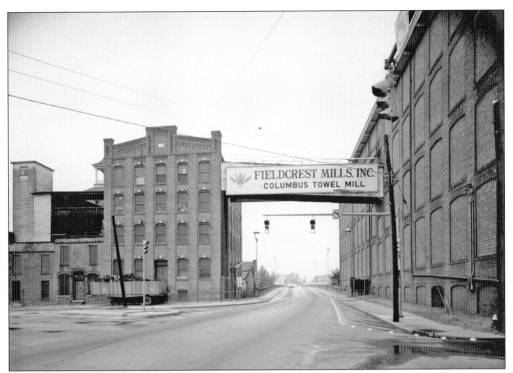

The Fieldcrest Mills Inc. ran the Columbus Towel Mill. This was one of many textile companies that operated mills in Columbus because of the access to the Chattahoochee River and nearby cotton fields. Columbus quickly grew to become a leader in the textile industry of the South. (Library of Congress.)

Workers are pictured leaving the Manchester Mill in Macon. This Central Georgia textile mill had capital of $100,000 and a spindle count of over 10,000 in 1901. The Manchester Mill would not allow Lewis Hine to take photographs of the workers inside the mills. (Library of Congress; photograph by Lewis Hine.)

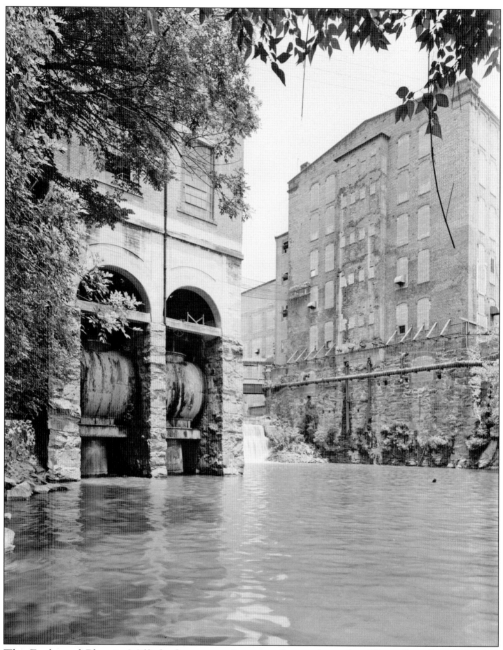

The Eagle and Phenix Mills hydropower plant was located on the Chattahoochee River in Columbus. The power generated from the river was used to operate all three mill facilities. (Library of Congress, Historic American Engineering Record.)

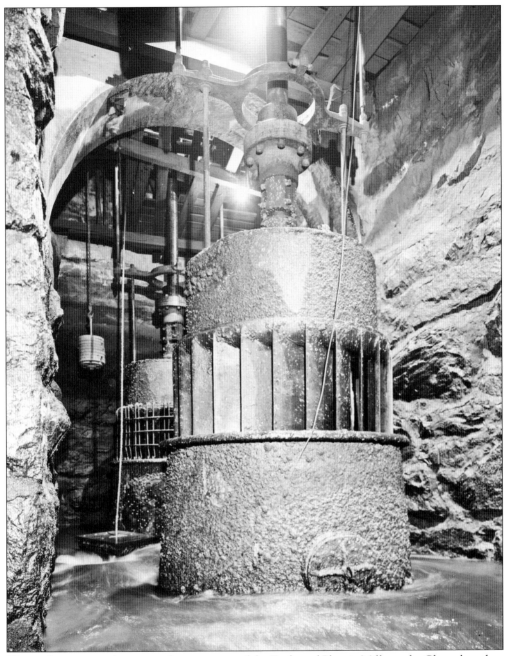

This turbine was used to power the generators of the Eagle and Phenix Mills on the Chattahoochee River. The success of the Eagle and Phenix Mills depended upon the river as a power source. (Library of Congress, Historic American Engineering Record.)

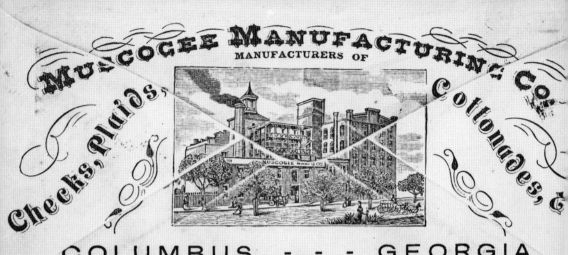

Pictured is the letterhead of the Muscogee Manufacturing Company, located in Columbus. The mills produced textiles such as cottonade, a heavy, coarse cotton fabric often used in work clothes. The Muscogee Manufacturing Company was established by the Swift family, owners of the Swift Mills; S.G. Murphy; and John J. Grant. Many mill owners in Columbus invested in multiple textile operations. This textile mill had been in operation since the 1870s. This letterhead was used for official letters from the mill as well as packages and official documents. It might also appear in a very similar form in advertisements. Use of the image with consumers helped create a brand that could be recognized and trusted. (Library of Congress, Historic American Engineering Record.)

Two

THE SOUTHERN TEXTILE MILL WORKER

In the early days of the textile mills, the businessmen who owned the mills liked the idea of keeping families together, as it created a more loyal workforce. Entire families came to work in the mills, and many of them were provided with company-owned housing and services.

Often, widows would come to mills knowing that they would be guaranteed housing and employment for themselves and their children. Children of all ages worked in the mills during the early 1900s, before the age of child labor laws. Many times, younger children were preferred to adults because they had small hands and were able to climb onto the equipment. There was not much regulation of labor. Photographer Lewis Hine set out to document child labor in the textile mills and other industries across the country. His photographs helped change the laws around child labor. Because of labor strikes, the Great Depression, and changes in labor laws, the mill workforce changed to become predominantly white and male.

During World Wars I and II, there were shortages of male workers, and women returned to fill their place making textile products for the war effort. Segregation of the workforce also occurred until the 1960s. Black workers were given menial or hard tasks, but eventually they did come to work the same jobs as the white workforce. However, black workers did not receive the same benefits or get to live in the same mill community as the white workers.

Mill workers did enjoy many benefits and perks, but many still tried to seek better employment. As the mills became more technologically advanced, a number of workers were forced to seek other means of employment. The towns and cities that once had a large percentage of their citizens working in the textile mills were slowing forgetting their industrial past.

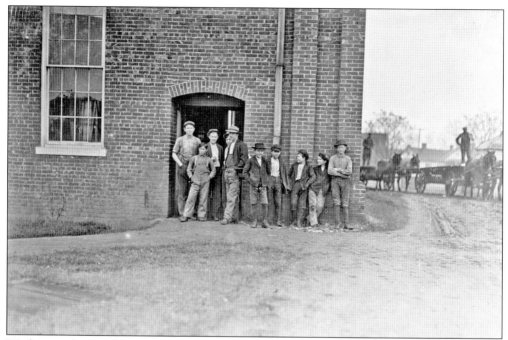

Workers at the King Mill in Augusta pose for the photographer on their noon break in 1909. Many of the workers are young boys. These boys worked long, hard hours for very little pay so that they could help their families. (Library of Congress; photograph by Lewis Hine.)

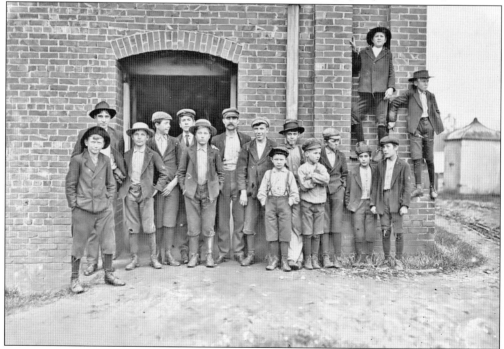

Another group of textile workers is on noon break at the King Mill. The children who worked in the mills are taking advantage of the pause for a photograph to behave like young boys by climbing on the building. (Library of Congress; photograph by Lewis Hine.)

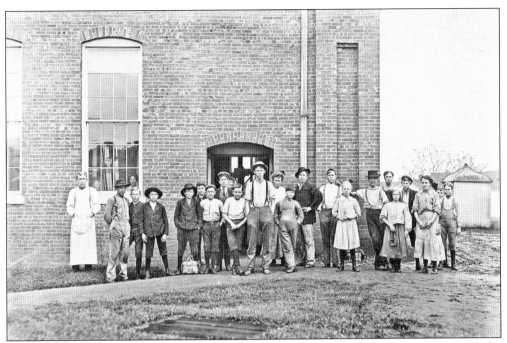

In this image of the textile workers of the King Mill on their noon break, the gathering includes female workers of all ages. Notice the cotton stuck to their clothes; the young workers were exposed to many adverse working conditions. (Library of Congress; photograph by Lewis Hine.)

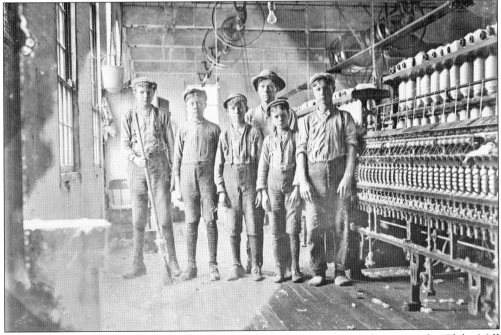

A man and young workers clean up the cotton around the textile machinery in the Globe Mill in Augusta. The mills did have some electric lighting, but most of the light came through the windows. These young doffer boys pose for the photographer in 1909. (Library of Congress; photograph by Lewis Hine.)

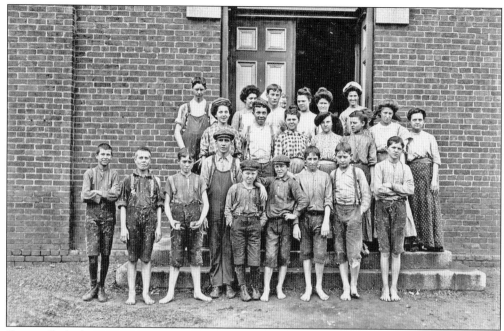

Cotton-flecked young workers stand with adults in front of the King Mill in 1909. Notice that many of the young boys are not wearing shoes, probably because they could not afford them for their growing feet. (Library of Congress; photograph by Lewis Hine.)

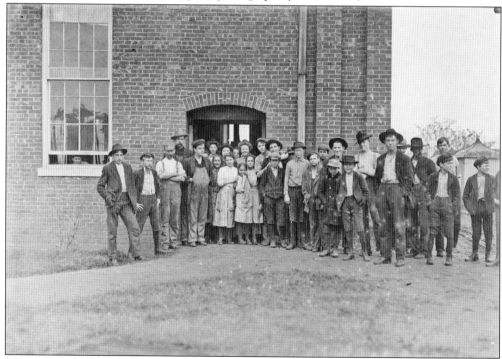

In another view of the textile workers of the King Mill, one can see that the workforce was made up of men, women, and children, many of them family members. The children would start out at the mills helping the parents. (Library of Congress; photograph by Lewis Hine.)

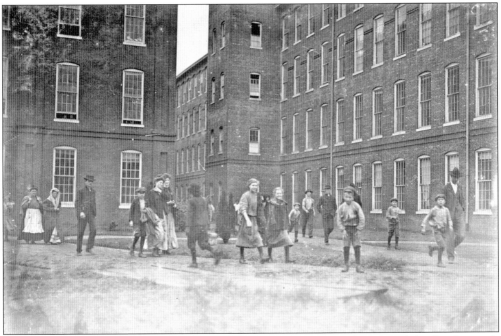

Textile workers of all ages leave the King Mill for their noon break. Most of the families with adults and children working at the mill would walk home together. Many lived nearby and could walk home for lunch. (Library of Congress; photograph by Lewis Hine.)

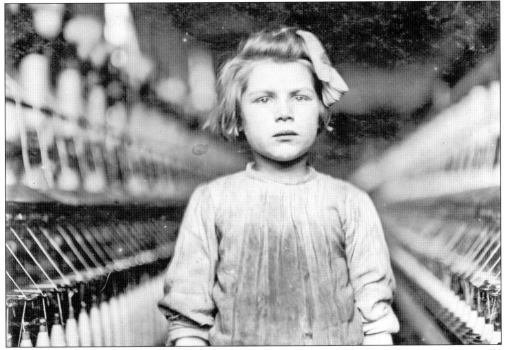

This little girl stands in front of machinery. She would be responsible for making sure the spindle threads ran smoothly in the textile production. Children like this young spinner girl worked many hours a day at the Globe Mill in Augusta. (Library of Congress; photograph by Lewis Hine.)

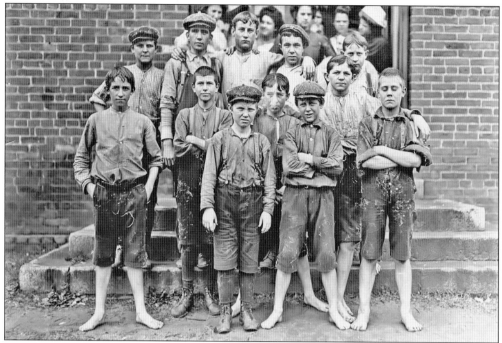
Young boys at the Enterprise Mill in Augusta had jobs alongside adults and seemed much older than their age. They spent their days covered in cotton instead of being covered in dirt from playing outside. The child laborers of the mills did not get to enjoy the playtimes of other, better-off youth. (Library of Congress; photograph by Lewis Hine.)

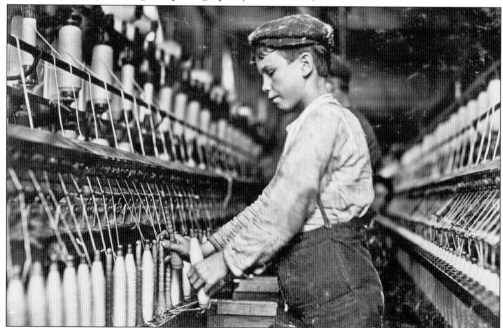
A young doffer boy tends the spindles on the textile equipment in the Globe Mill. Young children were chosen for tasks like this because of their small hands and their ability to quickly change out the spindles, work that required speed. (Library of Congress; photograph by Lewis Hine.)

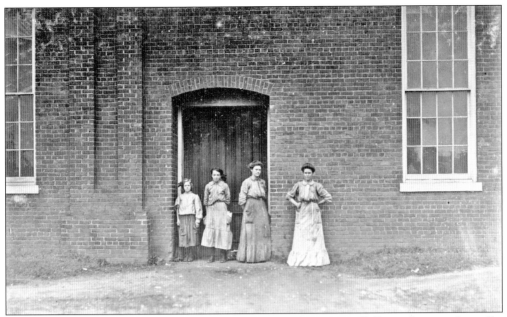

A group of young women of all ages poses in front of the King Mill. By working at the mills, women were allowed some freedom that the average housewife in the early 1900s would not have had. However, they lived hard lives and worked long hours. (Library of Congress; photograph by Lewis Hine.)

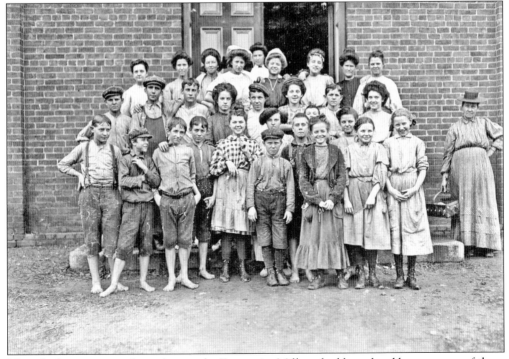

Though the young textile workers at the Enterprise Mill worked long, hard hours, many of them were still able to have fun with their coworkers. As in this photograph, the youngsters enjoyed cutting up. (Library of Congress; photograph by Lewis Hine.)

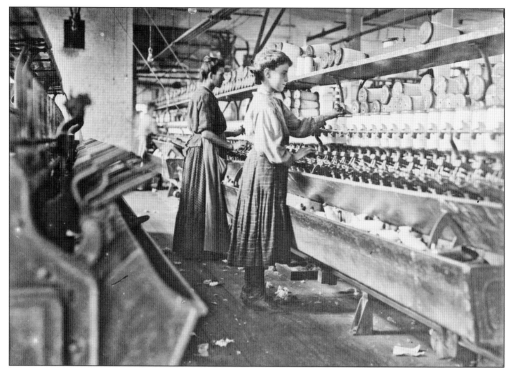

Young women in the Globe Mill change out spools of cotton yarn and keep a watchful eye on the textile equipment. These women worked long hours on their feet all day for low wages. One of the women is with child, and the photographer was told the workers usually worked up until the day of childbirth. (Library of Congress; photograph by Lewis Hine.)

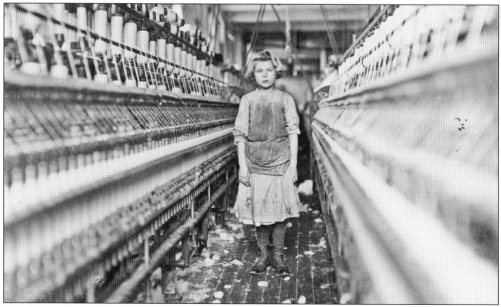

A young girl dressed in rags tends the massive textile spinner equipment in the Globe Mill. Children were responsible for running fast-moving and dangerous machinery that even today most adults would find daunting and unsafe. (Library of Congress; photograph by Lewis Hine.)

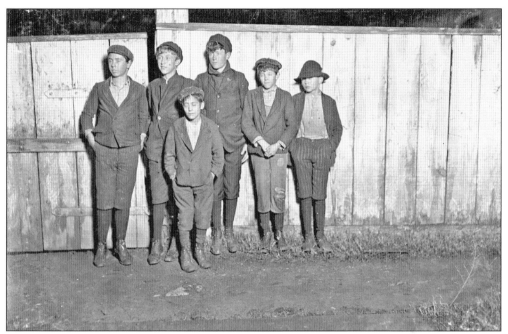

Young boys pose for the photographer by flashlight as they leave work for the day outside of the King Mill. The workers put in shifts of all hours no matter their age. (Library of Congress; photograph by Lewis Hine.)

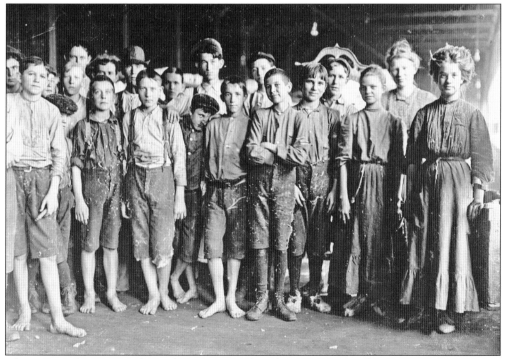

This group of young textile workers is pictured at the Enterprise Mill in Augusta during their noon break. Though their work was hard, the young workers knew that their wages helped support their families. (Library of Congress; photograph by Lewis Hine.)

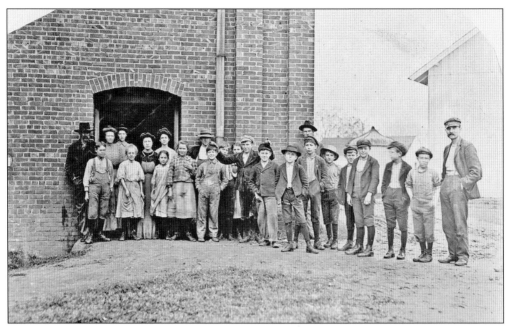

In this photograph of young mill workers and their families, a few of the boys up front take the opportunity to cut up with one another by placing objects on another boy's head. Though the young workers did not have an easy life, they were able to bond and have camaraderie with other mill workers, creating lasting friendships. (Library of Congress; photograph by Lewis Hine.)

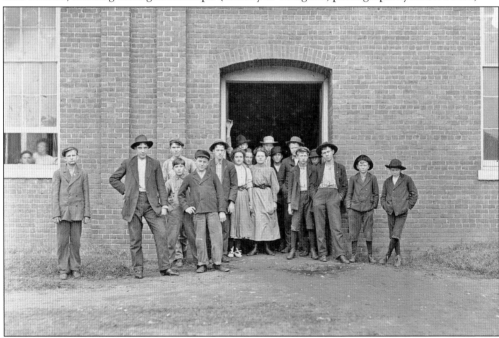

Another group of workers of all ages poses in front of the King Mill in Augusta. Photographer Lewis Hine was interested in the dynamics of the families of textile workers, why children were being allowed to work alongside adults, and why it was viewed as normal to employ children. (Library of Congress; photograph by Lewis Hine.)

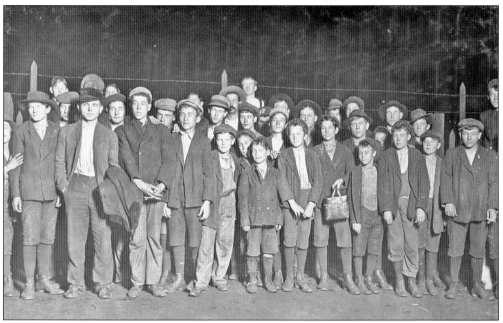

A group of textile workers, young and old, works the night shift at the Sibley Mill in Augusta. Young children worked long day and night shifts. Their families depended on the wages from the children to help make ends meet. (Library of Congress; photograph by Lewis Hine.)

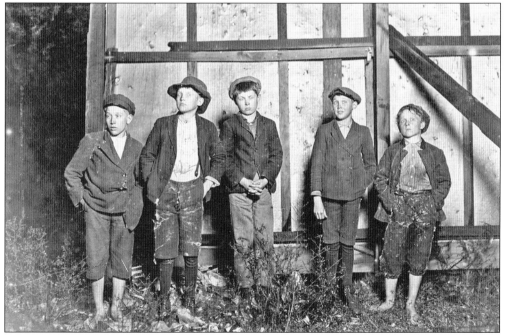

Young textile mill workers are pictured outside the cotton mills in Augusta. Employing young workers kept costs down for the mill owners, and also helped the poorer families be able to make ends meet in Augusta. The photographer had to sneak around to get some of the photographs of child laborers, as the mill owners would hide the children from visitors. (Library of Congress; photograph by Lewis Hine.)

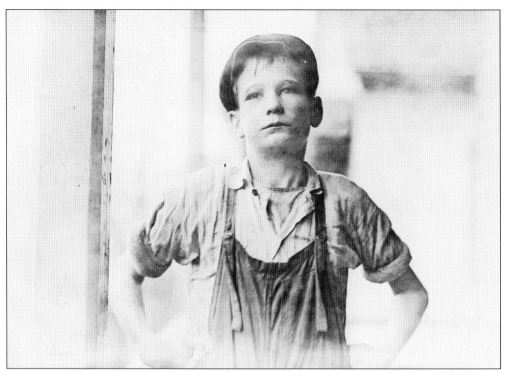

A young boy textile worker poses on the porch of a mill house in Central Georgia. Lewis Hine took his photographs to help capture the struggle of the child laborers and to change the way people saw how the other half lived. (Library of Congress; photograph by Lewis Hine.)

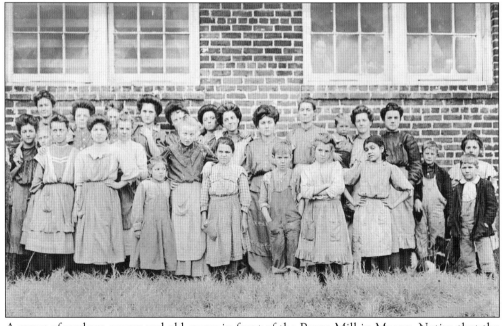

A group of workers, young and old, poses in front of the Payne Mill in Macon. Notice that the Gibson Girl hairstyle was very popular for the women workers in the mill even though they were doing manual labor. (Library of Congress; photograph by Lewis Hine.)

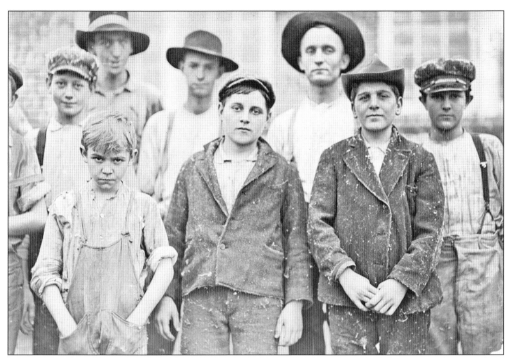

Young workers are covered in cotton from working in the Payne Mill. The cotton that stuck to their clothes was dangerous to their health, as the workers breathed in cotton dust created by the textile process. (Library of Congress; photograph by Lewis Hine.)

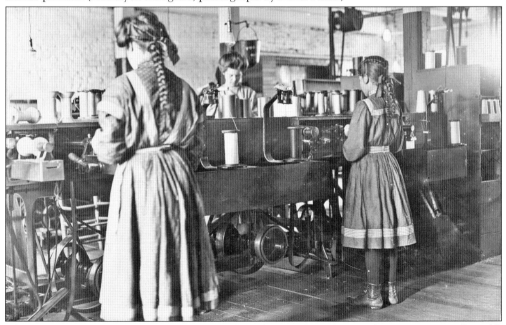

These young girls wear intricate hairstyles while they work on the textile equipment in the Bibb Mill No. 1 in Macon. They wore their hair up so that it would not get caught in the equipment. The equipment the child laborers operated was still dangerous and could easily cause injuries. (Library of Congress; photograph by Lewis Hine.)

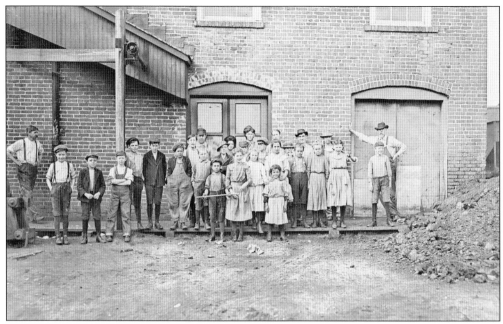
Outside of the Bibb Mill No. 1, a group of young textile workers poses with some older male workers. This was the headquarters of the Bibb Manufacturing Company, which operated mills in Macon and across Central Georgia. (Library of Congress; photograph by Lewis Hine.)

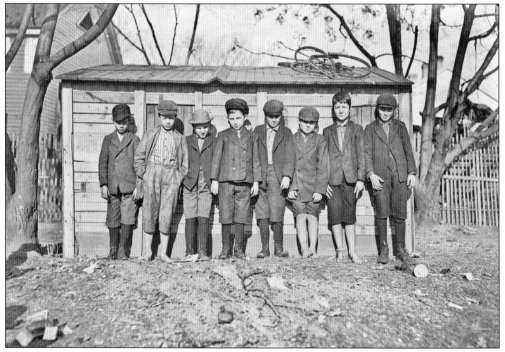
This group of young boys, standing in front of a shed in Bibb Mill No. 1 Village, worked at the mill to help support their families. Notice the difference in quality of clothing, as the children with finer clothes had been employed at the mill longer. (Library of Congress; photograph by Lewis Hine.)

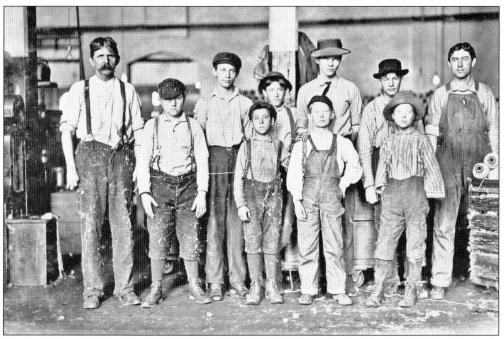

Textile workers pose in the Bibb Mill No. 1. The inside of the mill in the early 1900s was dimly lit, and cotton fibers littered the floor. The unsafe and unhealthy conditions that the textile workers were subject to was even worse for the child laborers and their growing bodies. (Library of Congress; photograph by Lewis Hine.)

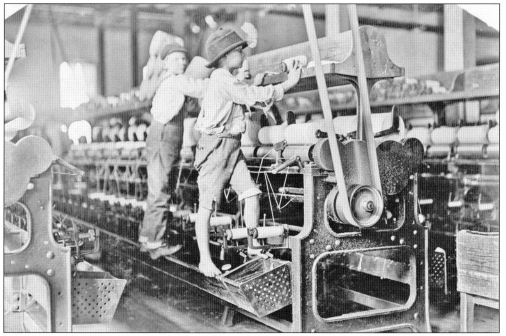

Two young boys climb up on the equipment to reach the bobbins at the Bibb Mill No. 1. Lewis Hine showed these images of children working in dangerous conditions to the public across America in his campaign to reform labor laws. (Library of Congress; photograph by Lewis Hine.)

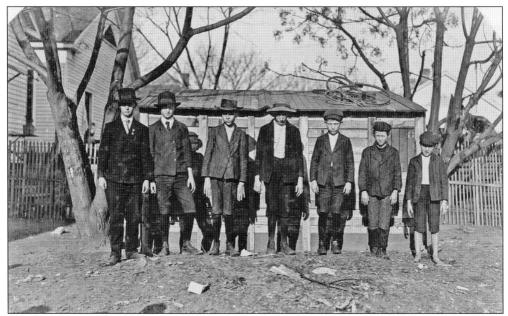

Another group of young men and boys stands in front of a shed at the Bibb Mill No. 1. The boys on the left have just started after moving from the country to work at the mill for 50¢ per day. The other boys have worked at the mills for years and are making up to 75¢ per day. (Library of Congress; photograph by Lewis Hine.)

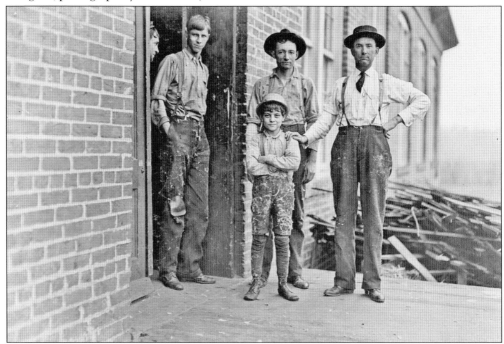

This young textile worker poses with an overseer at Payne Cotton Mill in Macon. The young boy earned 52¢ per day and had worked at the mill for two years. By employing children to do lesser jobs, the mills could get the labor cheaper and save on costs. (Library of Congress; photograph by Lewis Hine.)

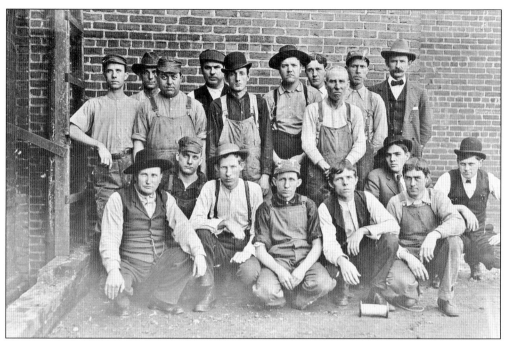

At the Bibb Mill No. 1, a group of supervisors and overseers poses for a photograph outside the mill. The management of this mill helped give Bibb Manufacturing Company a regular profit of almost 100 percent, which quickly made it one of the most profitable companies in the South. (Library of Congress; photograph by Lewis Hine.)

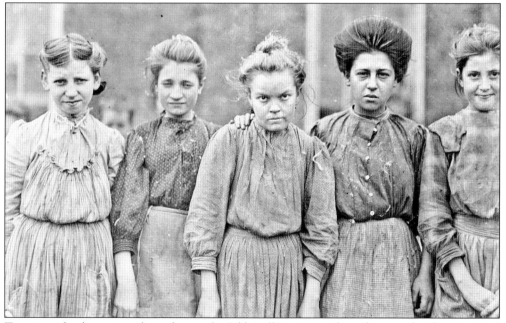

Teenage girls who are textile workers at the Bibb Mill No. 1 pose for a photograph. The exhausted lives of these young women, who lived and worked at the Bibb Mill No. 1 Village, was vastly different than those who lived just across the river in the grand houses of downtown Macon. (Library of Congress; photograph by Lewis Hine.)

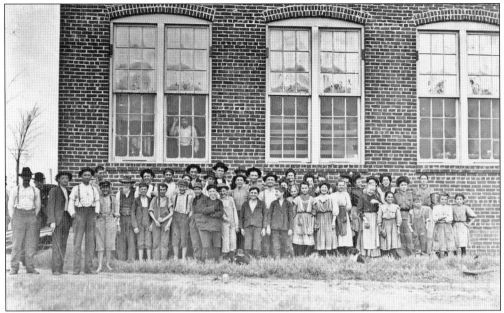

A group of textile workers of all ages and a small dog have fun getting their photograph taken outside the Payne Mill in Macon in 1909. Payne Mill was once located on what were the outskirts of Macon in Payne City, part of the company town of Bibb Manufacturing Company. (Library of Congress; photograph by Lewis Hine.)

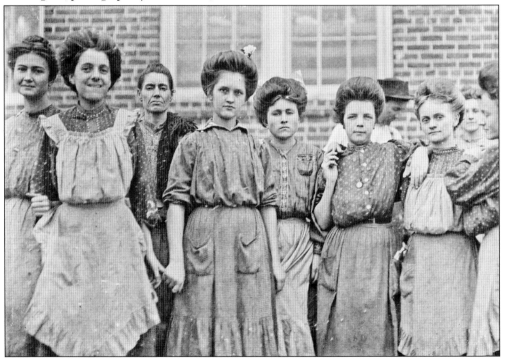

Pictured in January 1909 is a group of young and old women who were textile workers in the Payne Mill. Their hard work has aged them beyond their years but created an obvious bond between the women. (Library of Congress; photograph by Lewis Hine.)

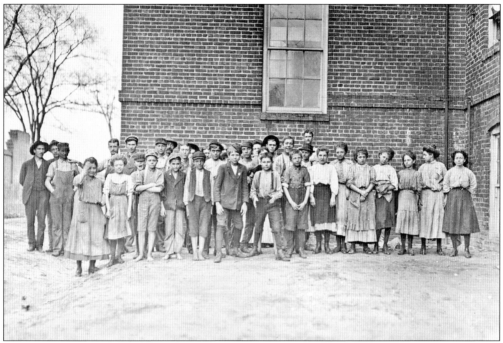

Young textile workers pose with their overseers outside the Bibb Mill No. 2 in Macon. They all regularly worked at the mill to help support their families. (Library of Congress; photograph by Lewis Hine.)

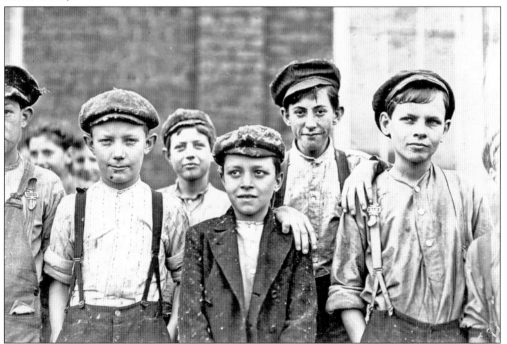

Doffer boys, like these at the Bibb Mill No. 1 in 1909, were responsible for replacing the bobbins on the spinning machines. Their small hands and speedy movements were the reason they were chosen for this task. (Library of Congress; photograph by Lewis Hine.)

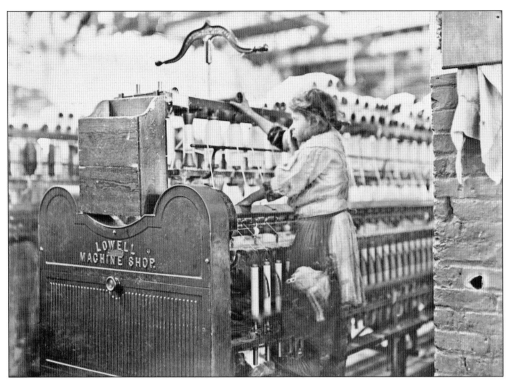

A young girl replaces a bobbin on the textile equipment in the Bibb Mill No. 1. Due to her size, she had to climb on the equipment to reach the bobbins. Children were often hired to work in the mills because they could easily fit their hands inside equipment. (Library of Congress; photograph by Lewis Hine.)

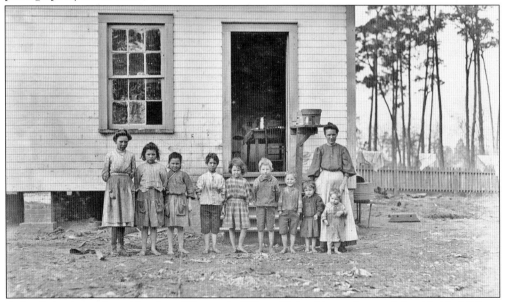

A family is pictured outside of a mill house in Tifton. This widow, who was left with 11 children, had to leave the farm to come find work. The five oldest children worked alongside their mother at the Tifton Mills. (Library of Congress; photograph by Lewis Hine.)

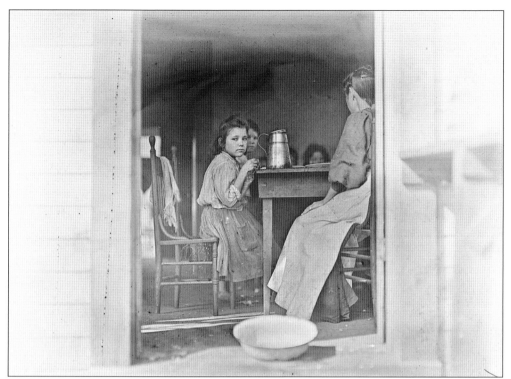

A family of textile mill workers from the Tifton Mill sits down for a meal in January 1909. They live in a mill house in the small village that grew up around the Tifton Mill in rural Central Georgia. (Library of Congress; photograph by Lewis Hine.)

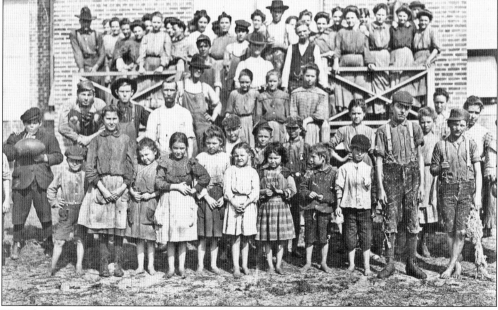

The whole workforce of 125 employees comes out for a photograph in front of the Tifton Mills. It looks like about half of the workers are children, who worked and lived in very rough conditions. (Library of Congress; photograph by Lewis Hine.)

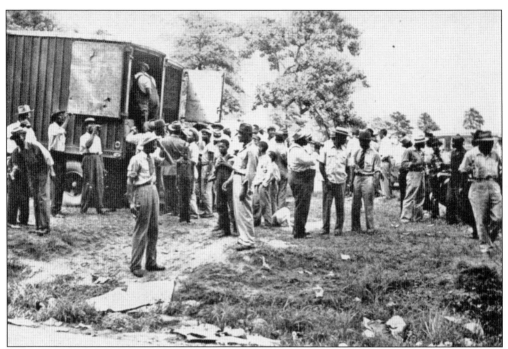

African American textile workers from the Bibb Mill are preparing to have a barbecue sponsored by Bibb Manufacturing Company. Though the black and white workers worked alongside each other in the mills, many company activities were still segregated until desegregation became the norm of the local community. (*Bibb Recorder*, Terry Webb.)

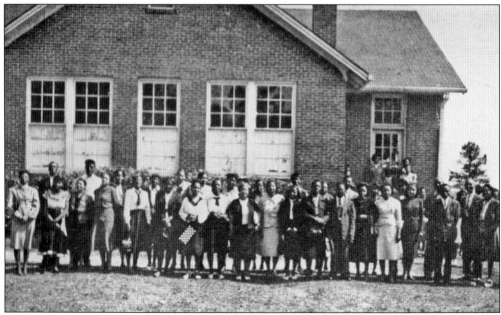

This photograph is of the school for the children of African American workers at the Bibb Mills. Many of the mills in Central Georgia did try to provide educational services for all of their workers' families, though the mill village housing and amenities were only for the white workers. (*Bibb Recorder*, Terry Webb.)

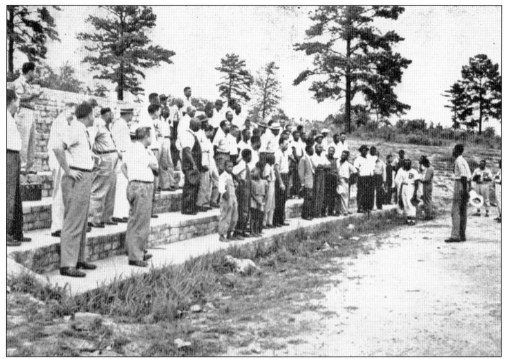

Adjacent to the Bibb Mill No. 1 Village was Drake's Field, which was a recreational park for the residents and workers of Bibb Mill No. 1. In this photograph, a mixed-race crowd watches the Bibb baseball team, which consists of African American players. During the 1950s, there was still segregation in much of the work and activities that surrounded the mills of Central Georgia. (*Bibb Recorder*, Terry Webb.)

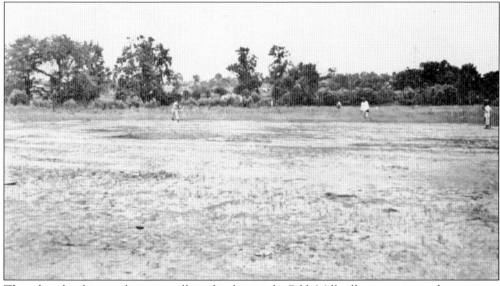

Though only white workers were allowed to live in the Bibb Mill villages, at times, the company did sponsor activities for African American workers. These African American workers are having a company baseball game at Drake's Field. By owning these recreational facilities, the company could provide many benefits to its employees. (*Bibb Recorder*, Terry Webb.)

In this image of the Mary-Lelia Cotton Mills in Greensboro, striking textile workers set up a picket line. Laborers would often strike to try to force mill owners to meet their demands for improved pay, benefits, hours, and working conditions. (Library of Congress; photograph by Jack Delano.)

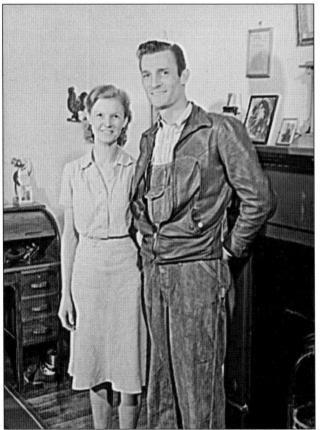

This handsome young couple in Greensboro poses for the photographer in 1941. The husband, Mr. Mayfield, was a young textile worker at the Mary-Lelia Cotton Mills. By the mid-20th century, securing a job at the local textile mill was seen as a good career choice and a prospect for future benefits. (Library of Congress; photograph by Jack Delano.)

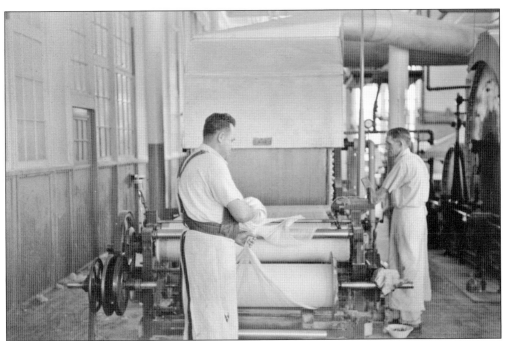

This textile worker is pulling cotton yarns off the line. The process to create textile fabrics took many steps. First the cotton had to be spun and turned into yarn, then the yarn was turned into the textile fabrics. There were also multiple other processes involved when creating other cotton products. (Library of Congress; photograph by Jack Delano.)

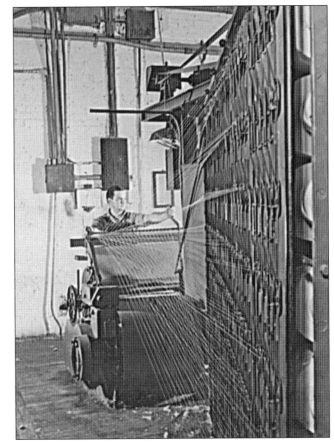

A textile mill worker tends to machinery at the Mary-Lelia Cotton Mills in Greensboro, Georgia. This photograph was taken in 1941, when equipment was becoming more modern with ever-changing technologies. (Library of Congress; photograph by Jack Delano.)

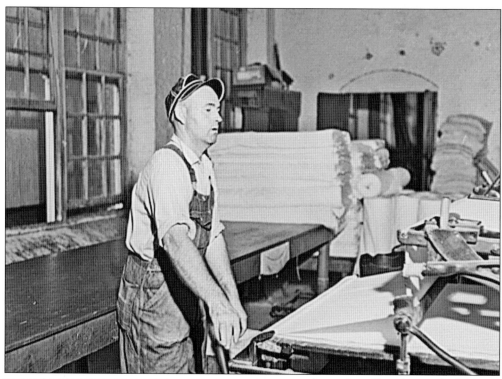

A textile mill worker in the Mary-Lelia Cotton Mills in 1941 tends to the textile fabric that is coming off the line. Behind him are stacks of fabric produced in the textile mill. The mills made a wide variety of fabrics. (Library of Congress; photograph by Jack Delano.)

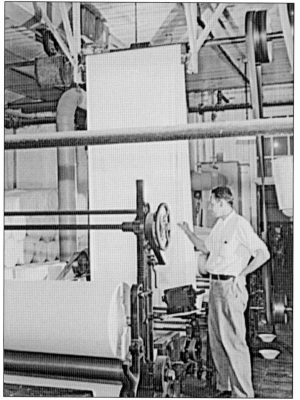

This textile worker inspects the fabric as it comes off the line in the Mary-Lelia Cotton Mills. The rolls of fabric that the textile mills have produced are lining up against the walls of the mill. (Library of Congress; photograph by Jack Delano.)

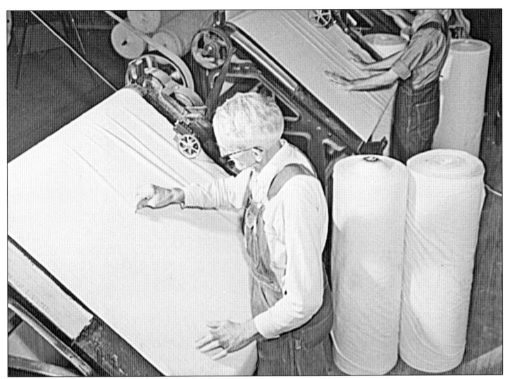

As the fabric is being produced at the Mary-Lelia Cotton Mills, the textile workers go over it to inspect the weaves. By inspecting the textile fabric as it comes off the line, the manufacturer can control the quality of the product. (Library of Congress; photograph by Jack Delano.)

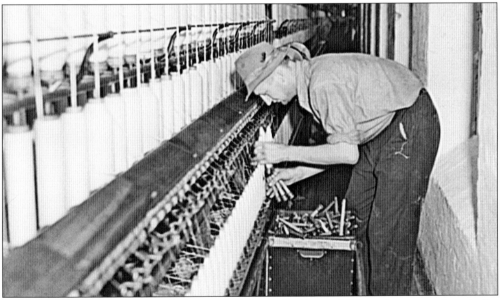

A textile worker bends down on the line in the Mary-Lelia Cotton Mills to change out the spindles on the machinery. By 1941, when this photograph was taken, the machinery had become more automated, but the spindles still had to be changed out by hand. (Library of Congress; photograph by Jack Delano.)

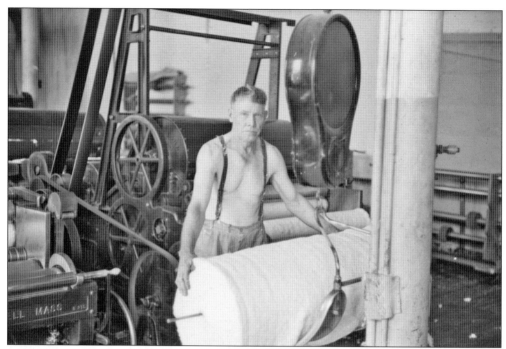

This shirtless textile worker in suspenders is weighing fabrics produced in the Mary-Lelia Cotton Mills. By weighing the fabric rolls on a hanging scale, he knows that the fabric is made correctly with the right fabric weight and density. (Library of Congress; photograph by Jack Delano.)

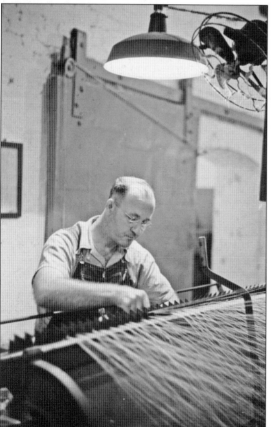

In Greensboro, this textile worker inspects the yarns of the fabric as it is loaded into the textile machinery at the Mary-Lelia Cotton Mills. By keeping a close eye on the yarns, he is able to make sure the fabric is being produced correctly. (Library of Congress; photograph by Jack Delano.)

A female textile mill worker removes spindles of yarn from a textile machine in the Mary-Lelia Cotton Mills. Though she wears a dress while she works in the mills, she is able to utilize her apron to carry her work supplies. (Library of Congress; photograph by Jack Delano.)

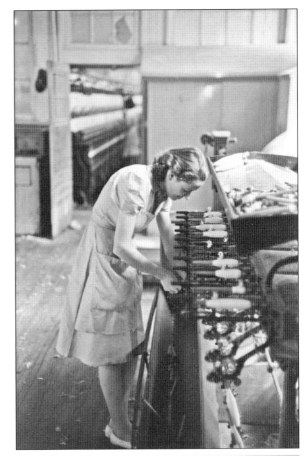

A female textile mill worker inspects the yarn threads that go into producing the fabrics at the Mary-Lelia Cotton Mills. The mills were a large employer and helped to industrialize the rural community of Greensboro. (Library of Congress; photograph by Jack Delano.)

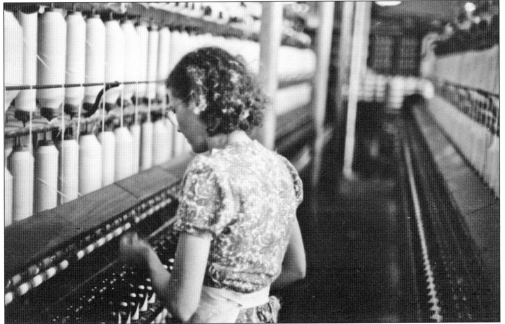

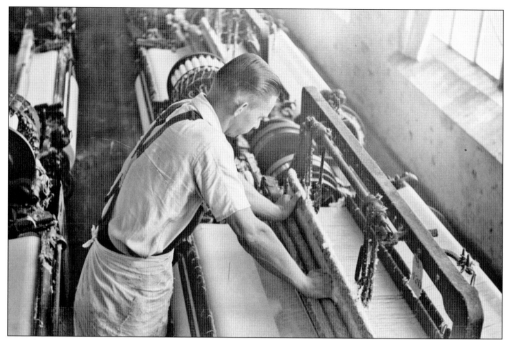

A worker operates a textile machine in the Mary-Lelia Cotton Mills. The textile worker has his hands on top of the operating machinery. The way that the textile machinery workers once worked regularly around moving machinery would not be considered safe in textile mills today. (Library of Congress; photograph by Jack Delano.)

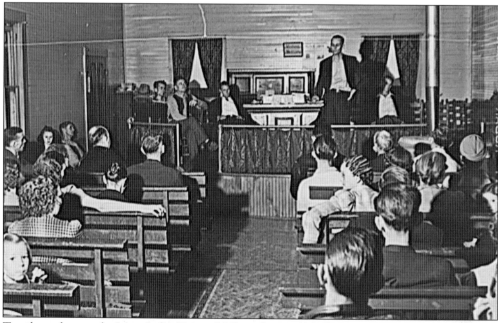

Textile workers at the Mary-Lelia Cotton Mills gather in 1941 for a union meeting to discuss the matters of the mill from the employees' perspective. Because of the unions, working conditions, pay, and benefits in the textile mills of Central Georgia greatly improved in the first half of the 1900s. (Library of Congress; photograph by Jack Delano.)

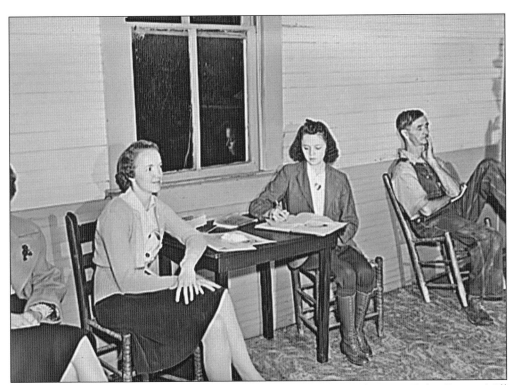

In this photograph, a group of young female textile workers from the Mary-Lelia Cotton Mill attend a union meeting. Women workers in 1941 had important roles in the textile mills, and they stuck together with other textile employees as they participated in the local union. (Library of Congress; photograph by Jack Delano.)

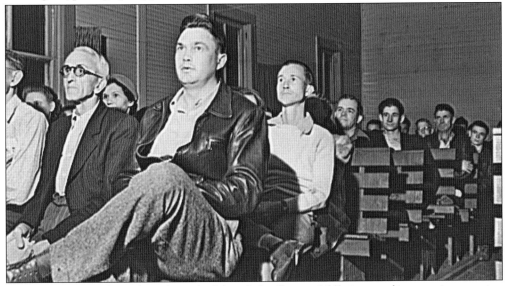

This group of textile workers from the Mary-Lelia Cotton Mills is attending a union meeting in 1941. Unions became very important to the textile workers across Central Georgia; thanks to them, workers were able to secure jobs with good wages, benefits, and security. (Library of Congress; photograph by Jack Delano.)

SEPTEMBER

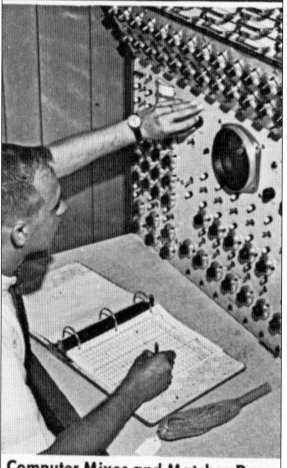

Computer Mixes and Matches Dyes

As the modern age came to the textile mills, computers were introduced to help better operate the equipment. Though technology replaced the jobs of many workers, it also created technical jobs for workers who had to operate the new computer equipment. (*Bibb Recorder*, Terry Webb.)

Bibb Manufacturing Company sponsored an employee golf tournament for its workers. These activities helped create teamwork and communication within the mills. Providing extracurricular activities for textile workers helped boost morale and company loyalty for the textile mills in Central Georgia. (*Bibb Recorder*, Terry Webb.)

Winners at Snow Open Golf Tournament

With big business came many phone calls that had to be routed by hand by the switchboard operators during the mid-20th century at Bibb Manufacturing Company. Calls came in from all over the world and the many different offices and locations where Bibb did business. These behind-the-scenes office employees were an integral part of the textile industry. (*Bibb Recorder*, Terry Webb.)

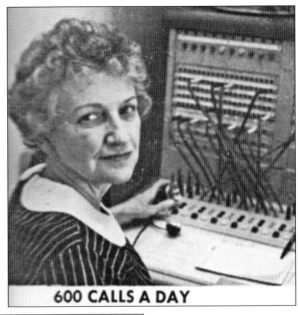

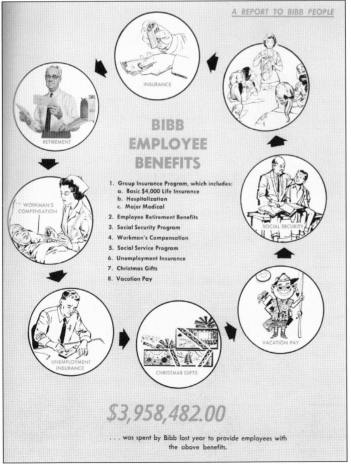

Textile workers not only received a paycheck for their work, but many were loyal to the company because of the extra benefits they received. This is a breakdown of the benefits of an average Bibb Manufacturing Company employee in the 1950s. Over the years, the employee benefits changed due to company profits. (*Bibb Recorder*, Terry Webb.)

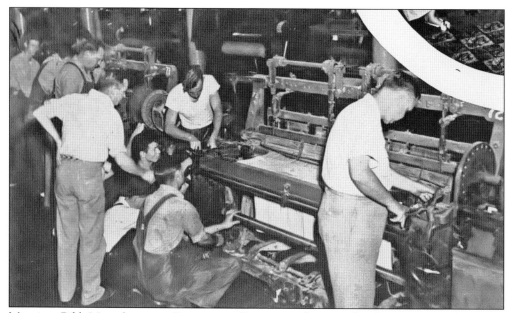

Men in a Bibb Manufacturing Company mill are at work on outdated equipment. Though by the mid-20th century much of the equipment had been modernized, particular older pieces of equipment were kept around for certain uses. Many of the machines were specialized just to create a particular type of textile or design. (*Bibb Recorder*, Terry Webb.)

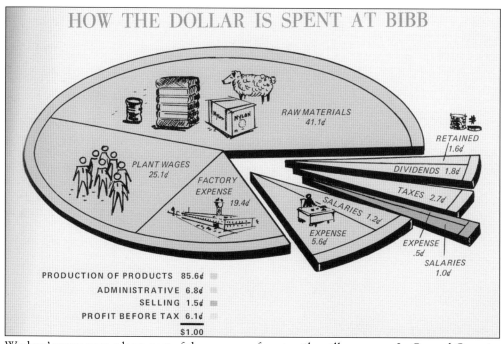

Workers' wages were a large part of the expenses for a textile mill company. In Central Georgia, many of the mills were spending 25 percent of their costs on wages. By the 1960s, the days of textile companies making 100-percent profits were a thing of the past. (*Bibb Recorder*, Terry Webb.)

Three
LIFE IN A MILL VILLAGE

A shared community is what the mill villages gave the textile mill workers' families. From the early days until the Baby Boom era, many mill workers lived and worked under the shadow of the textile mill company.

When workers were recruited to the mills, they were given the option of living in housing provided by the mills. If they choose to live in the mill village, they were assigned housing based on their position and their family situation. The cost of rent and other services that were provided by the mill was taken out of the worker's paycheck. The textile mill companies were not just employers but were overseers of an entire town.

Besides housing, the textile mills established schools, clinics, and community centers for their workers. The mill village was part of a family labor arrangement much like sharecropping, which many of the workers had been used to in the rural areas of Central Georgia. As time went on, mill villages become more of a community the residents treasured. In the larger mill villages, there was everything that a family could need, including entertainment.

Some of the largest and most significant mill villages in Central Georgia were Bibb City in Columbus, the Bibb Mill No. 1 Village in Macon, Harrisburg in Augusta, Payne City in Macon, and Porterdale on the Yellow River. These villages had housing for single individuals and for large families. The housing was usually laid out in a planned community with bungalow kit houses, often in the preferred duplex style to condense the employee housing.

By the 1960s, times were changing. Many employees wanted to move away from the mill village, and the textile mills wanted to no longer be landlords to their employees. Originally the mill houses were offered for sale to their employees, but eventually they were available for anyone to purchase. As employees moved away from the mill villages, the community services that the textile mills provided were no longer needed and were closed, as was a bygone era.

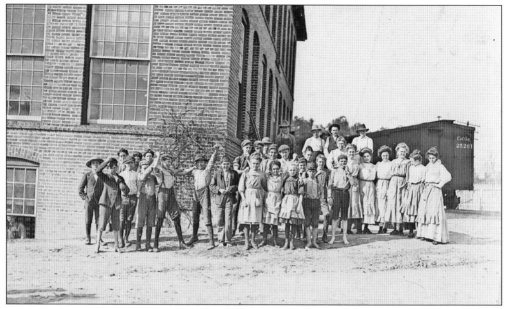

A group of textile workers poses outside a textile mill in Central Georgia. These young workers lived in the textile mill village and like many young adults in their day had to work at the mills to support their family. The child laborers of the early 1900s did not have the idyllic childhood of the children who grew up in the villages only a few decades later. (Library of Congress; photograph by Lewis Hine.)

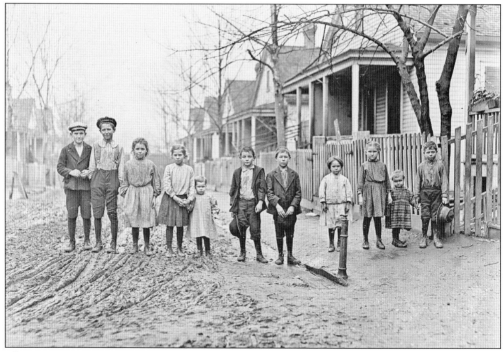

This group of young children stands in the street of the Gregtown mill village, where the textile workers of King Mill lived in Augusta. Most of the children in this photograph had been working in the King Mill for up to four years. (Library of Congress; photograph by Lewis Hine.)

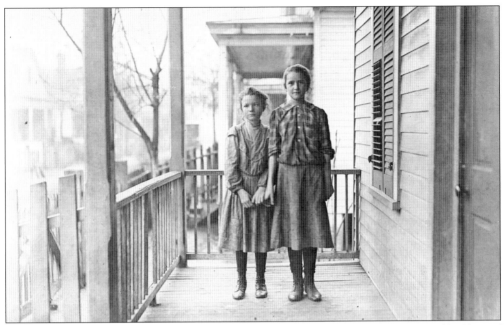

Two young textile workers of the King Mill stand on the porch of a house in the mill village of Gregtown. Eunice Lambert (left) and Nellie McKinney had been working at the King Mill for two years at the time of this 1909 photograph. (Library of Congress; photograph by Lewis Hine.)

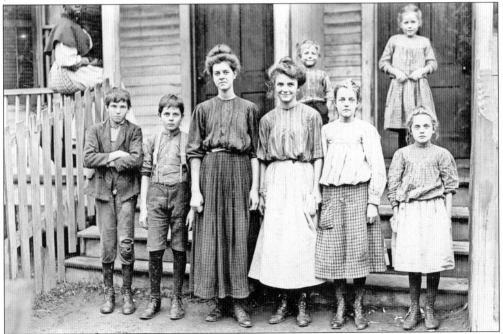

This interesting photograph shows a family of workers at the King Mill standing in front of their mill housing. All six of the family members worked at the King Mill. Note the African American woman sitting on the porch; during the time of this photograph, 1909, only white workers lived in the mill village. This lady could have been a friend of the family or possibly hired help to tend the house or watch the young children. (Library of Congress; photograph by Lewis Hine.)

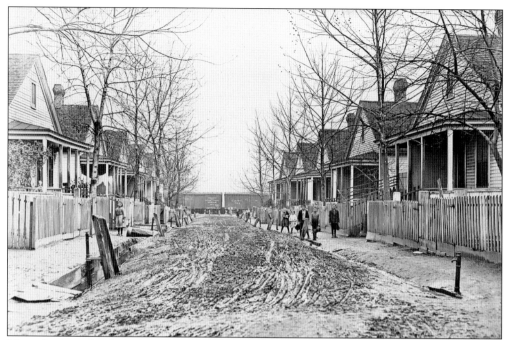

This photograph of an average street in a textile mill village was taken in Gregtown. The villages were planned by the textile mills, and the housing was very similar. (Library of Congress; photograph by Lewis Hine.)

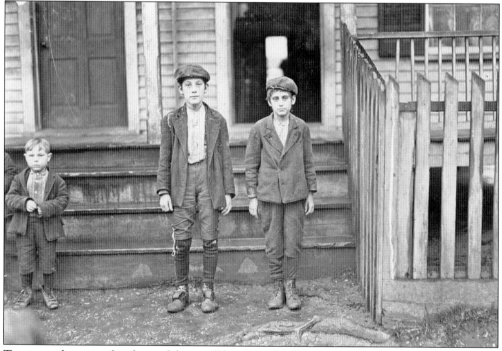

Two young boys stand in front of their mill house in the Gregtown mill village. The mill house is split into a duplex to save space. A large family would live in just one side of the house. (Library of Congress; photograph by Lewis Hine.)

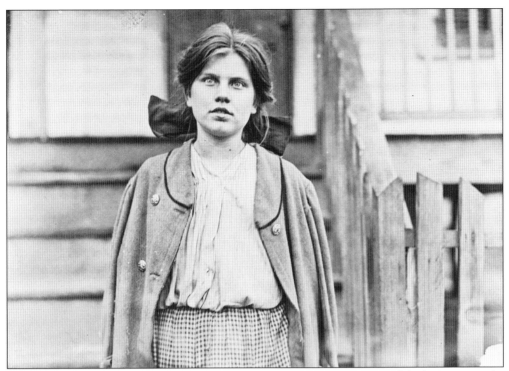

A young lady stands in front of her textile mill house in Augusta. King Mill built Gregtown for its workers and their families. The families would have worked at the mills and had rent taken out of their wages. (Library of Congress; photograph by Lewis Hine.)

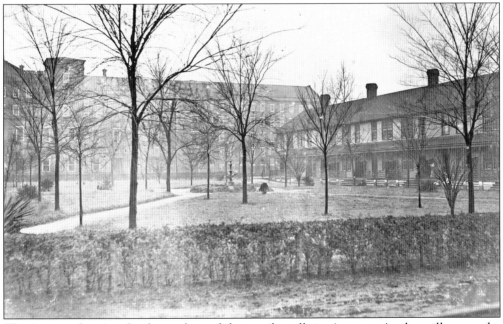

This is group housing for the workers of the textile mills in Augusta. As the mills grew, the need for housing for the workers did too, so to keep up with demand, the mills had to build large tenements. (Library of Congress; photograph by Lewis Hine.)

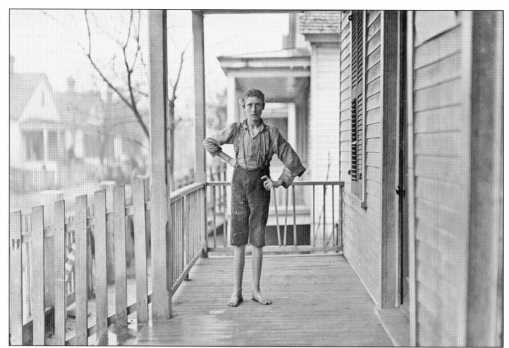

A young boy stands on the porch of his mill house in Augusta. He was 15 years old and had been working in a few different mills since the age of seven. The children had to work to help support the family and make ends meet. (Library of Congress; photograph by Lewis Hine.)

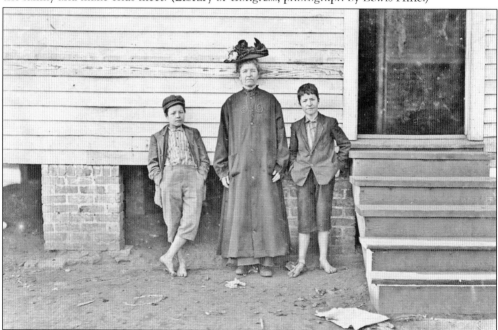

Widows such as Mrs. S.J. Bonner were a common sight at the textile mills across Central Georgia. In the early 1900s, women did not have many options for employment. The appeal of working at the mill with children was that they would be housed and they could all work at the mill to contribute to the household. (Library of Congress; photograph by Lewis Hine.)

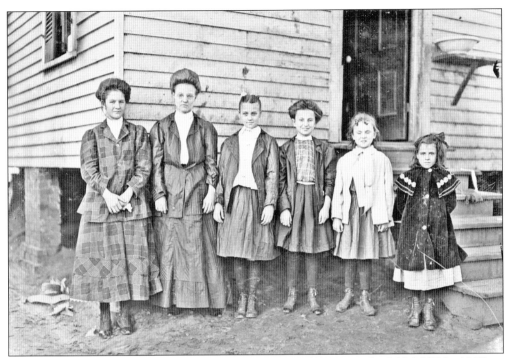

A group of nicely dressed women stands in front of their mill house in the Bibb Mill No. 1 Village in Macon. They were family and friends who had all been working at the mill for many years. (Library of Congress; photograph by Lewis Hine.)

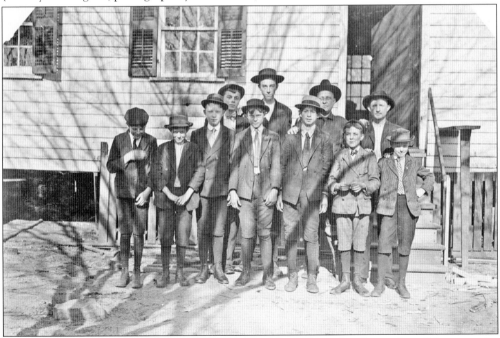

These sharply dressed textile workers of the Bibb Mill No. 1 stand in front of a mill house in the Bibb Mill No. 1 Village on the Ocmulgee River in Macon. Most of the boys had been working from one to four years. (Library of Congress; photograph by Lewis Hine.)

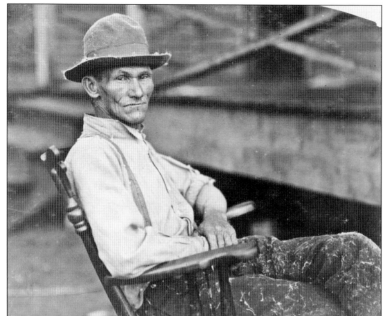

This man was considered a "dependent father" in that he depended upon his minor children to work to help support the family. He too would sometimes work in the textile mills of Columbus. In 1913, he had a total of 10 children working at the mills. (Library of Congress; photograph by Lewis Hine.)

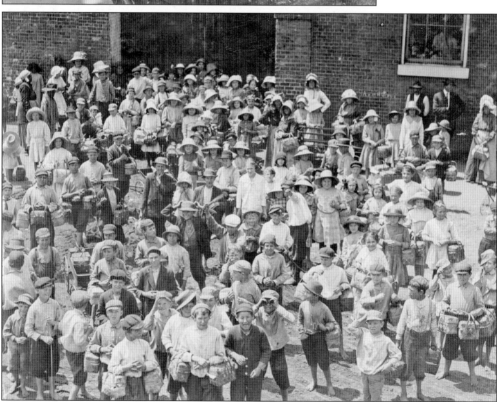

A large group of dinner toters waits for the gate to open so that they can get into the mill in Columbus in 1913. It was a popular tradition in Columbus and a means of getting the little ones accustomed to work in the mills. They would deliver food at the noon meal and help out mill workers. (Library of Congress; photograph by Lewis Hine.)

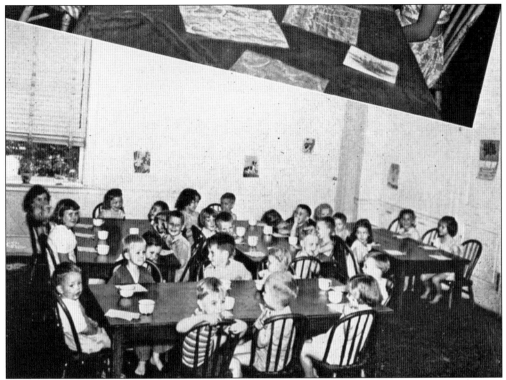

A company-sponsored day care was provided for workers' children in the Bibb Mill No. 1 Village. By providing child care, the company was able to provide a sense of community for the workers as well as a place for the children while the parents worked. (*Bibb Recorder*, Terry Webb.)

By the mid-20th century, the villages of Bibb Manufacturing Company had changed drastically. They provided many extracurricular activities for their workers and the families of those who lived in the mill village. This group of children of mill workers played in a community band. (*Bibb Recorder*, Terry Webb.)

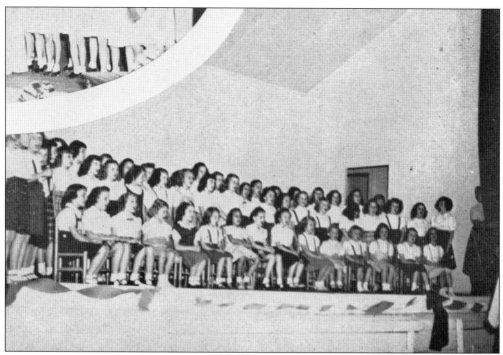

This community-sponsored chorus was made up of the young children of mill workers who lived in a Bibb Mill village. These young ladies not only enjoyed singing but were also able to provide entertainment for the workers who lived in the village. (*Bibb Recorder*, Terry Webb.)

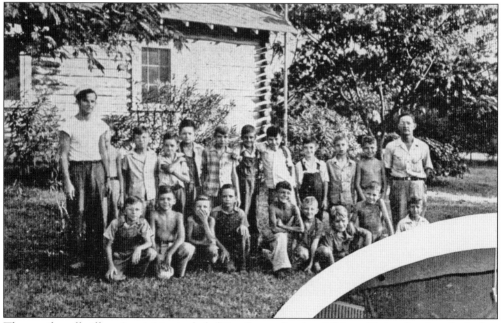

The textile mill villages' activities included Boy Scouts for the children. Only a few decades before this photograph, boys of a similar age would have been workers themselves at the mills. By the mid-20th century, adult workers were paid enough wages to support their families without having to have the children work to make ends meet. (*Bibb Recorder*, Terry Webb.)

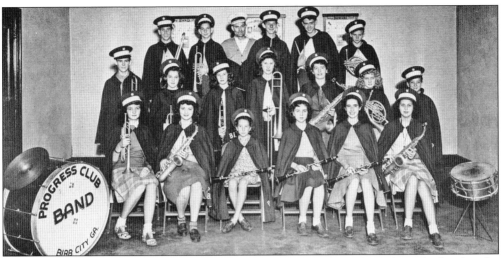

These young band members were the children of Bibb City Mill textile workers who lived in the mill village in Columbus. The Progress Club helped do good throughout the community of Bibb City. These community clubs were popular in the Bibb Mill villages of Central Georgia. (*Bibb Recorder*, Terry Webb.)

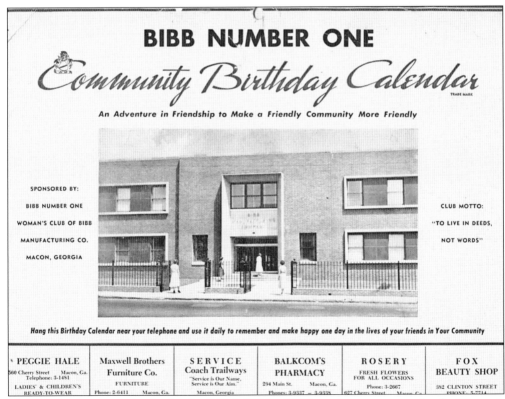

This is a community calendar for the Bibb Mill No. 1 Village that was put out by the Women's Club of Bibb Manufacturing Company. It listed the birthdays of the residents of the Bibb Mill No. 1 Village and listed local businesses as sponsors of the calendar. (Women's Club of the Bibb Manufacturing Company, Wayne Robertson.)

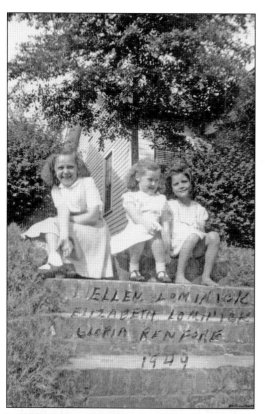

Three sweet little girls sit on the steps on the Bibb Mill No. 1 Village. The village created a safe community to grow up in because everyone who lived in the village knew one another and their parents worked together at the mill. (Elizabeth Lominick Bode.)

A local basketball team plays for the mill workers and children in a Bibb Mill village. By creating their own recreational departments and activities, the mills of Central Georgia helped create a sense of community teamwork in work and sport. (*Bibb Recorder*, Terry Webb.)

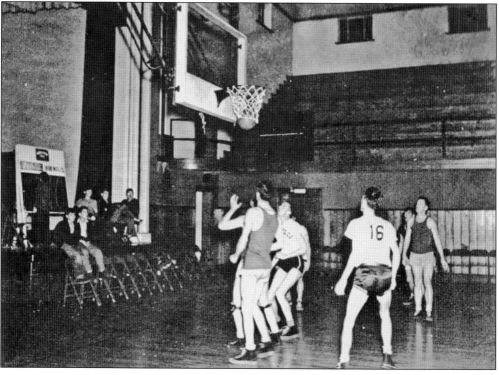

A speaker makes a presentation before a crowd of Bibb Mill textile workers in Central Georgia. The mill villages had their own community leaders outside of the elected officials of the nearby cities. (*Bibb Recorder*, Terry Webb.)

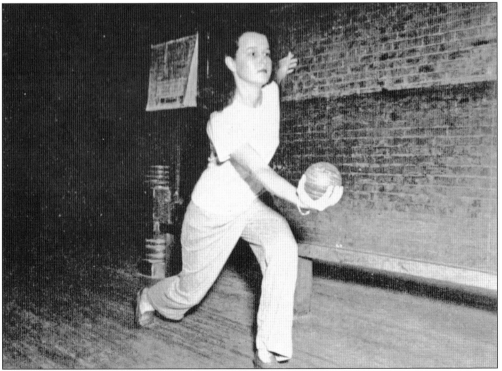

A young lady bowls in a bowling alley in a Bibb Mill village. Amenities like this for employees and families helped create company loyalty and worker satisfaction. Having all of the actives that one could want in a mill village made for a great quality of life. (*Bibb Recorder*, Terry Webb.)

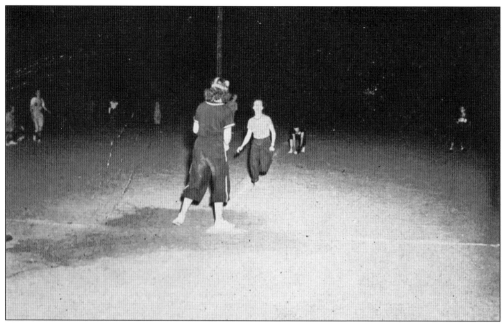

These young ladies play softball in a Bibb Mill village. These social activities created an opportunity to have fun and to get to better know the other families that lived in the Bibb Mill villages. (*Bibb Recorder*, Terry Webb.)

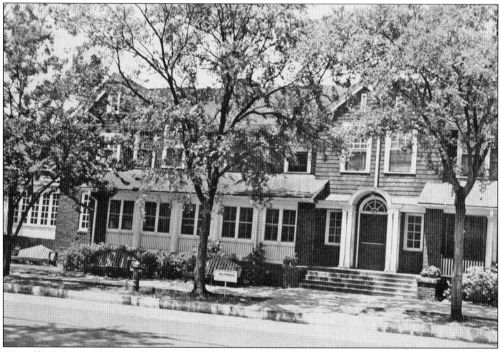

Not all of the workers at the Bibb Mills lived in a mill house. When single women and men came to work at the village, they were given the opportunity to live in a company hotel like this one in Porterdale. It was also handy for workers traveling to the different mills. (*Bibb Recorder*, Terry Webb.)

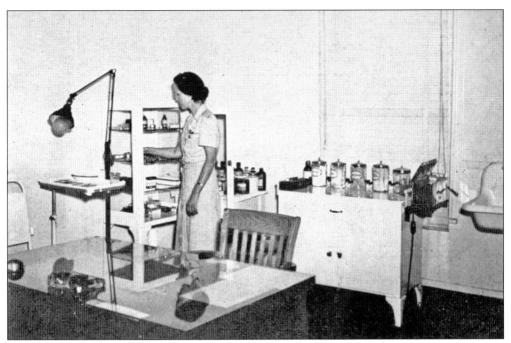

Many of the mills offered employees and families medical services in their very own clinics within the mill villages. By providing the workers and their families' medical services, the mills could keep healthy employees and happy families. (*Bibb Recorder*, Terry Webb.)

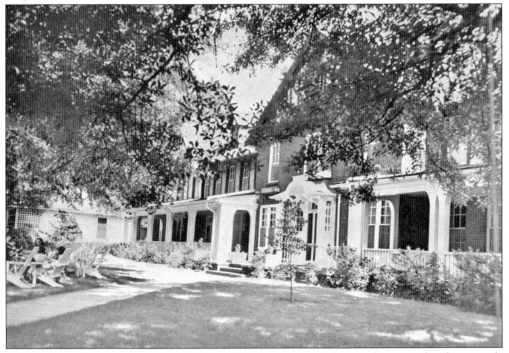

The hotels and community centers in the mill villages gave residents a place to gather, have meals and coffee, and socialize with other residents. With such amenities, the residents had little reason to leave the mill villages. (*Bibb Recorder*, Terry Webb.)

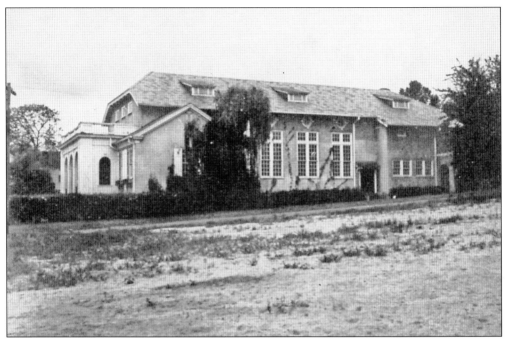

This view shows the community center of the Bibb Mill No. 1 Village, where children had parties and performances and played sports. At times, outside bands and performers played at this community center for the entertainment of workers of the Bibb Manufacturing Company and their families. (*Bibb Recorder*, Terry Webb.)

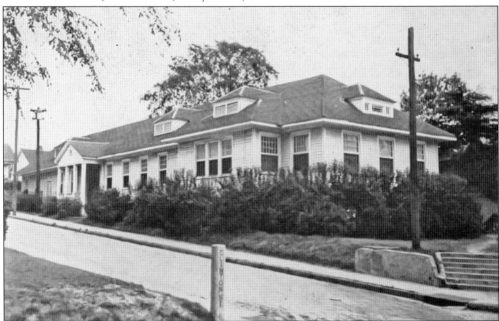

Pictured is a community center building in the Bibb Mill No. 1 Village in Macon on Clinton Street, which was a main street through the village. Clinton Street led to what was once a recreation area for Bibb Mill workers and is now part of Ocmulgee National Monument. (*Bibb Recorder*, Terry Webb.)

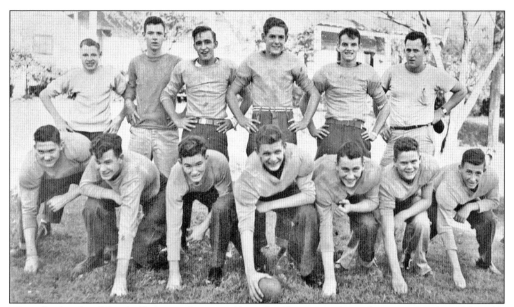

These high school football players from a Bibb Mill village pose for a photograph. The Bibb Mills sponsored many sports teams for the families of employees. These young men were the sons of textile mill workers for Bibb Manufacturing Company. (*Bibb Recorder*, Terry Webb.)

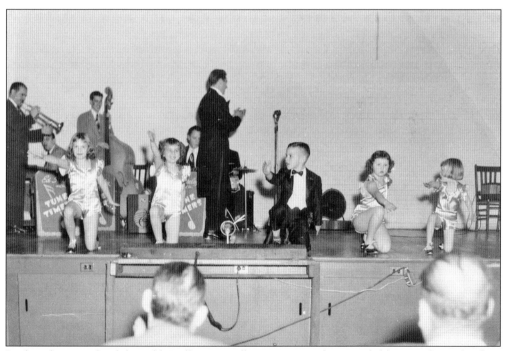

In this photograph of the Bibb Mill No. 1 Village, a group of young children performs for their families and other workers. The lives of the children of the village were enriched by the many actives they could enjoy because of the community surrounding the Bibb Manufacturing Company. (Elizabeth Lominick Bode.)

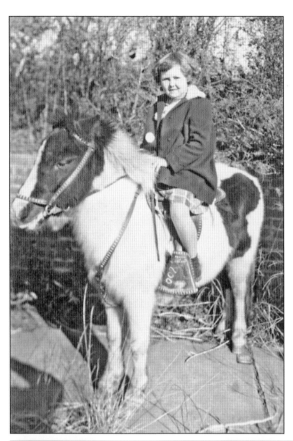

Elizabeth Lominick Bode is pictured as a little girl in the Bibb Mill No. 1 Village. Posing on ponies for photographs was a popular tradition in Central Georgia. The children of the mill workers in the mid-20th century lived a very different lifestyle than those only a few decades earlier. (Elizabeth Lominick Bode.)

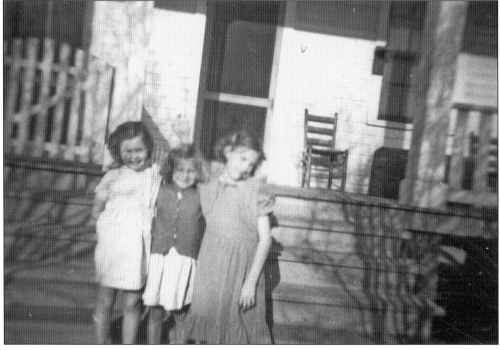

These young ladies, the children of textile workers, pose in the Bibb Mill No. 1 Village for a family snapshot. These friendships and living together in a mill village are still fond memories for former residents. (Elizabeth Lominick Bode.)

This early 1960s photograph shows Halloween in the village of the Bibb Mill No. 1. Children and adults are participating in a community event at the Bibb Auditorium in Macon. From left to right are two unidentified, Brenda Byrd, Lynda Byrd, Linda Walker Pruitt, Nancy Mosely Haselden, and unidentified. (Sarah and Terry Austin.)

Payne City was a mill village that surrounded Payne Mill in Macon. This was the community center for the residents of Payne City, which was a Bibb Manufacturing Company mill village. It was once near the textile mills but is no longer standing. (*Bibb Recorder*, Terry Webb.)

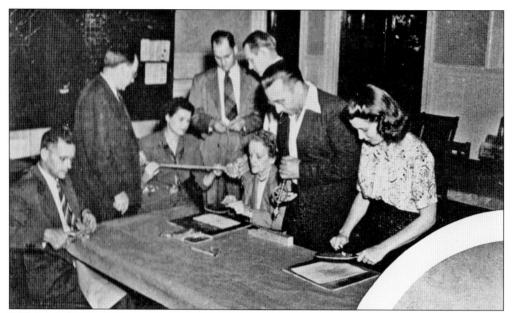

Bibb Manufacturing Company workers appear to be testing out new office equipment. Men and women both held important roles in the administration of the textile mills of Central Georgia. The benefits of the textile mills would have helped recruit both men and women to the workforce. (*Bibb Recorder*, Terry Webb.)

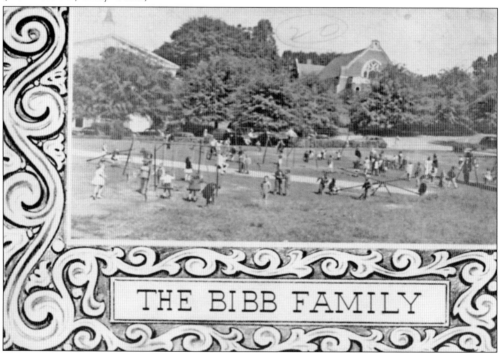

The Bibb Manufacturing Company liked to view its employees as family and looked upon its workers and their families in a sort of fatherly sense of caring for them. The company produced these family albums of what was happening at its many textile mills in Central Georgia and in the villages. (*Bibb Recorder*, Terry Webb.)

These matriarchal ladies of Porterdale churn ice cream for a community social event. The community of Porterdale grew up around the Porterdale mill on the Yellow River and was owned by the Bibb Manufacturing Company. The Porterdale community was tight-knit, as almost everyone was connected by the textile mills. (*Bibb Recorder*, Terry Webb.)

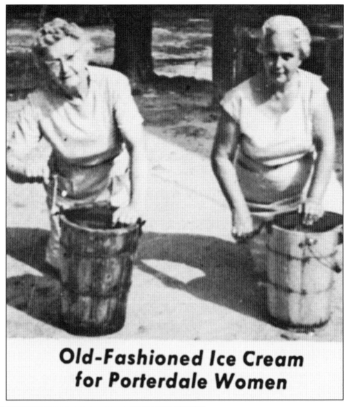

Old-Fashioned Ice Cream for Porterdale Women

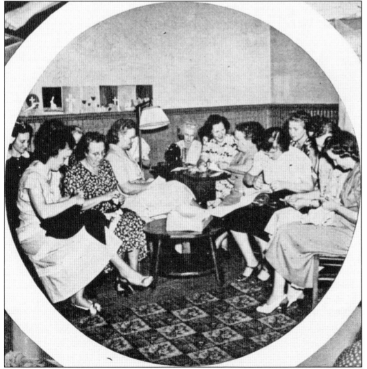

Sewing and quilting circles were a popular pastime and a necessity for the women in the villages of Central Georgia. Though the textile companies made fabric, textiles, and sometimes clothing, many families still made their outfits and bedding by hand, along with mending tears. (*Bibb Recorder*, Terry Webb.)

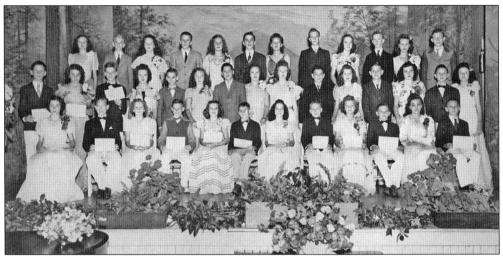

A group of finely dressed young graduates poses with their school certificates. These children of workers for the Bibb City Mill were provided an education through the schools sponsored by Bibb Manufacturing Company in Bibb City in Columbus. (*Bibb Recorder*, Terry Webb.)

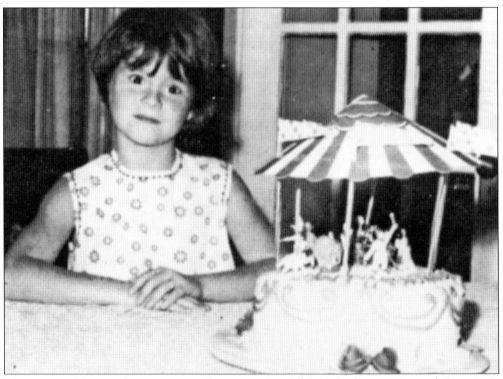

This young girl is the daughter of textile workers in a Bibb Mill village in Central Georgia. It appears that she is celebrating her birthday with a decorated cake by having a party in the mill village community center, which would have been a perk of living in the mill village. (*Bibb Recorder*, Terry Webb.)

Pictured is another community center for workers and their families in a Bibb Mill village. The Bibb Manufacturing Company provided the community centers for mill workers to have a place to hold community- and work-related events for employees and their families. (*Bibb Recorder*, Terry Webb.)

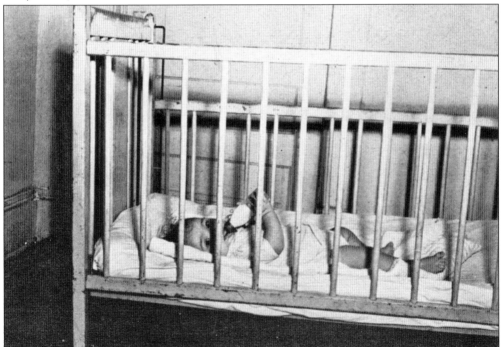

A young baby, the child of a textile worker, rests in his crib at day care provided by the Bibb Manufacturing Company in Macon. Child care services during the day freed up parents to work in the mill or tend to other chores. (*Bibb Recorder*, Terry Webb.)

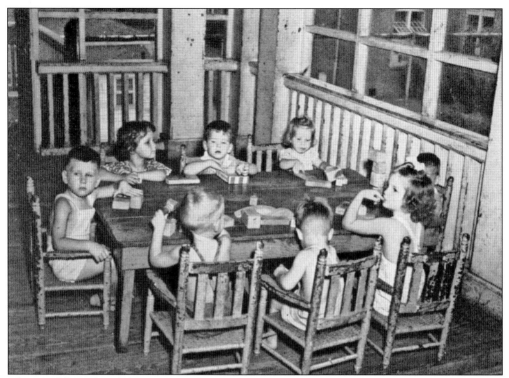

These toddlers, the children of textile workers at the Bibb Mill village, are enjoying a snack at their day care. Day care enriched the children's lives. (*Bibb Recorder*, Terry Webb.)

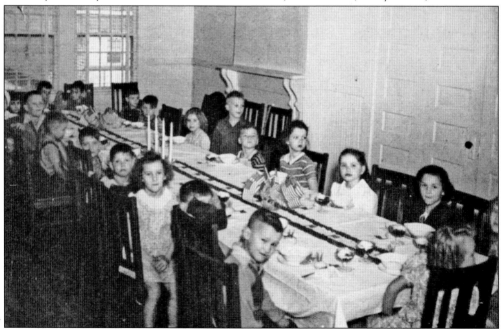

These children of textile workers from a Bibb mill are enjoying a formal dinner at the children's center with a patriotic-themed table. Providing these children an opportunity to learn manners helped create well-rounded residents of the Bibb Mill village. (*Bibb Recorder*, Terry Webb.)

These young girls, the children of textile workers from a Bibb mill, are enjoying finger painting at a mill-sponsored art class. Providing the children with enriching activities made them happy, and in some ways, they had more advantages than the children whose families had to provide activities on their own. (*Bibb Recorder*, Terry Webb.)

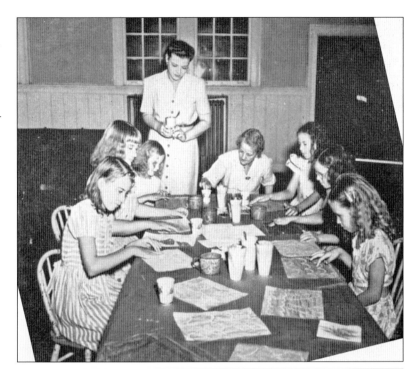

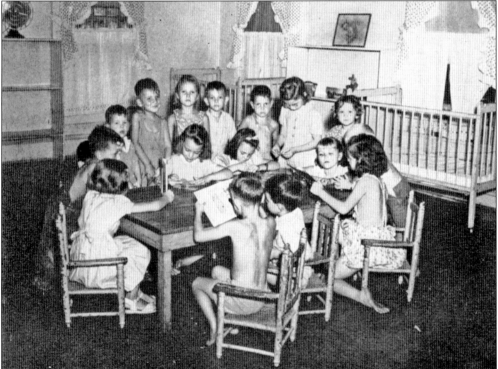

These children of textile workers are learning to read books at the day care provided by Bibb Manufacturing Company. These amenities made the workforce more likely to be loyal to the company and to be satisfied employees. (*Bibb Recorder*, Terry Webb.)

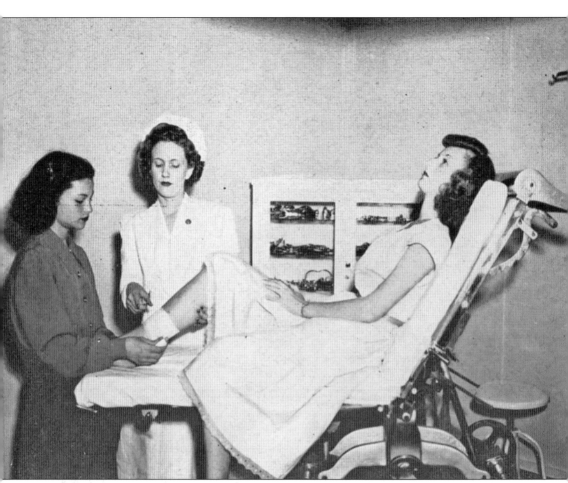

Medical services were available at the mill village, not just for the safety of the mill workers but also for the residents of the village. Having employer-sponsored health care not only saved the workers money but the textile mills as well. If the workers never had to go far for medical appointments, that would mean less time off work. (*Bibb Recorder*, Terry Webb.)

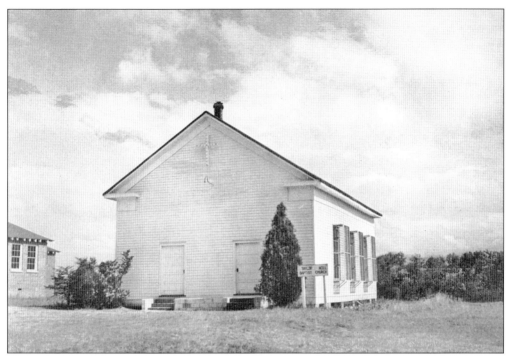

The Taylor Mill Baptist Church served the small mill village that supported the Taylor Mill outside of Reynolds. The country church still serves local residents. Near the church, many still live in the former mill village duplex-style houses. (*Bibb Recorder*, Terry Webb.)

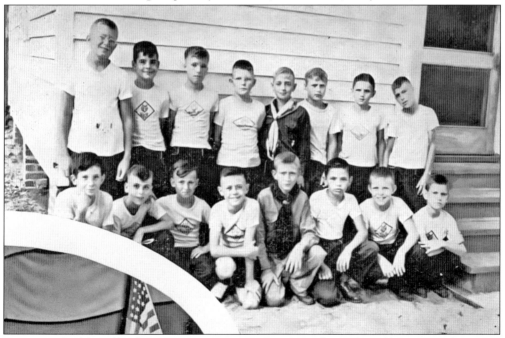

A group of Bibb Mill village Boy Scouts poses for a snapshot. The villages were their own communities separate from the nearby cities and had their own organizations and troops that consisted of just the families of the textile workers. (*Bibb Recorder*, Terry Webb.)

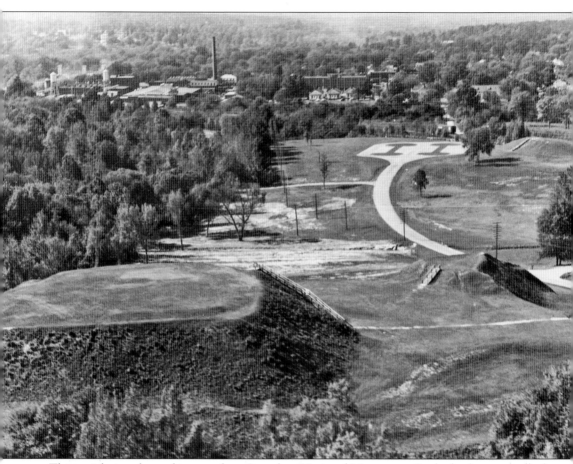

This aerial view shows the mounds at Ocmulgee National Monument. In the background, all of Bibb Mill No. 1 and the Bibb Mill No. 1 Village can be seen. This was the original location for Bibb Manufacturing Company. The smokestacks and the water towers are very visible as well as the proximity of the mill houses to the monument. The proximity of the Bibb Mills to the mounds caused disputes over the years regarding property lines and the ownership of the mounds. Because the mounds at Ocmulgee National Monument were so close by the Bibb Mill No. 1 Village, they became a favorite playground for the village children. The parents would tell their children stories of Indian lore to keep them from sneaking off to play on the mounds at night. (Ocmulgee National Monument.)

Four
A Changing Industry and the Future

After World War II, technology and culture were changing the textile industry. Mills were being desegregated, and mill communities were becoming a thing of the past as the mills sold the houses to the workers and the villages became incorporated into the nearby cities. New technology was being introduced in the mills that reduced the workforce.

The textile mills and companies were being transformed with new regulations that many could not keep up with. The old textile mill buildings were outdated, because many had occupied the same building for almost a century. It was difficult and expensive to modernize the mill buildings and the equipment. The workforce became smaller because of new equipment that replaced workers. New trade agreements and a push for cheaper labor led many textile companies to relocate overseas. Many mills were losing money in the changing globalized economy and tried to salvage the mills by condensing resources. Struggling mills were often bought by outside investors or larger textile companies, though eventually most of them were no longer profitable to operate and closed their doors.

The textile mills of Central Georgia had once been major employers for their communities, but most were shut down by the 21st century. These large buildings sat empty for many years and became a looming reminder of the past. As they sat deteriorating, many of the mills were lost due to arson or accidental fire. In recent decades, however, there has been a resurgence of interest in many of the old mill buildings to renovate them for new purposes, such as lofts, event venues, and restaurants. There is also a renewed interest in the community of mill towns, and many of the homes are being restored.

This chapter explores the closing of the textile mills and the current state of mills across Central Georgia. Each location is different. Some have been forgotten, some are treasured memories of a bygone era, and in some towns, the mills are considered a blight on the city.

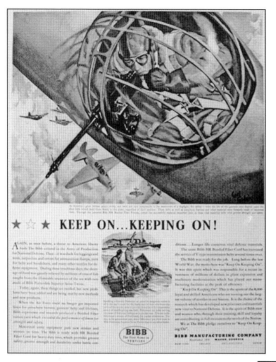

During the wars of the 20th century, Bibb Manufacturing Company, like other textile mills in Central Georgia, became a producer of war products. The mills changed over from making textiles for the home to producing items such as tents, blankets, and parachutes. The textile mills across Central Georgia were an important part of supporting the war efforts. (Bibb Manufacturing Company.)

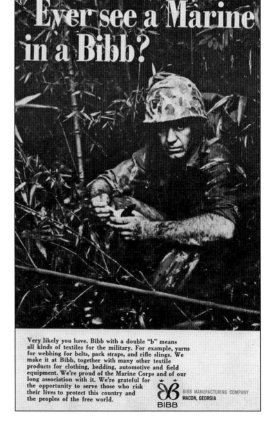

This advertisement for Bibb Manufacturing Company also serves as a piece of war propaganda to encourage America to keep up the effort on the home front. During World War II, Bibb Manufacturing Company was the largest war textile producer in Georgia. (Bibb Manufacturing Company.)

As this advertisement states, Bibb Manufacturing Company was the largest producer of war textiles in America. Its textile mills across Central Georgia played a large part in the war effort. The company produced a wide variety of products, and the mills were protected by military police so the products would be safe from tampering. (Bibb Manufacturing Company.)

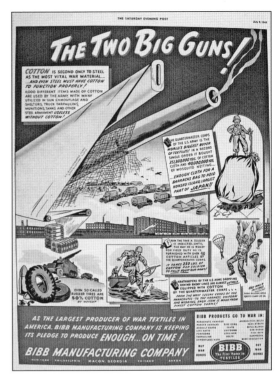

After World War II, modernization and new technologies transformed the textile mills of Central Georgia. In this photograph, a man is running modern equipment that replaced many workers. Along with the reduced need for workers, the work started to become more skilled and specialized. (*Bibb Recorder*, Terry Webb.)

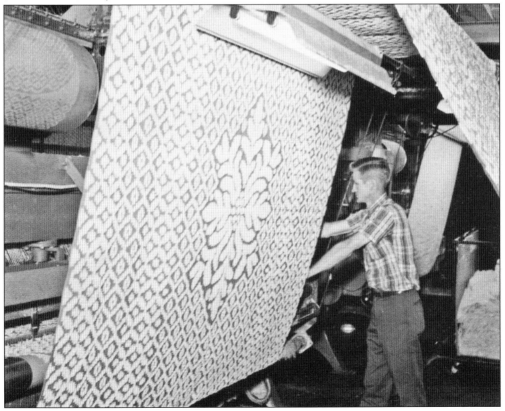

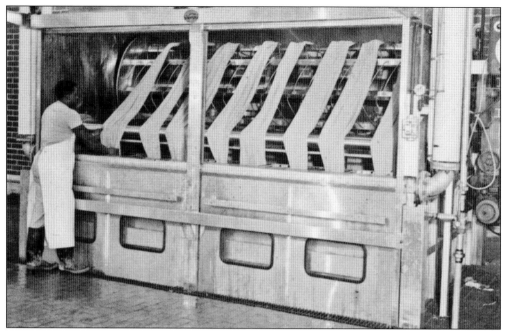

This textile worker is dying materials a blue color. As customers' tastes changed over the years, so did the designs of textiles. By the 1960s, the textile companies in Central Georgia were creating products in a variety of patterns, colors, and designs. (*Bibb Recorder*, Terry Webb.)

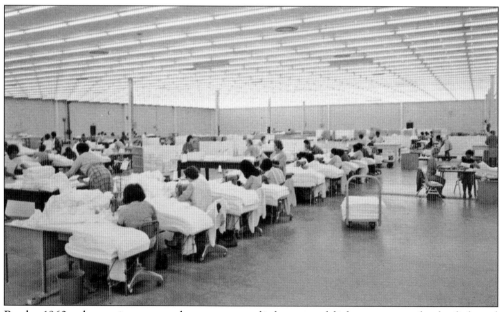

By the 1960s, the sewing rooms that were once lit by natural light were completely slick and modernized. Mills across Central Georgia made a variety of products from bedding to carpets to jeans to rope. Almost every type of cotton product made in America was being produced in a Southern textile mill. (*Bibb Recorder*, Terry Webb.)

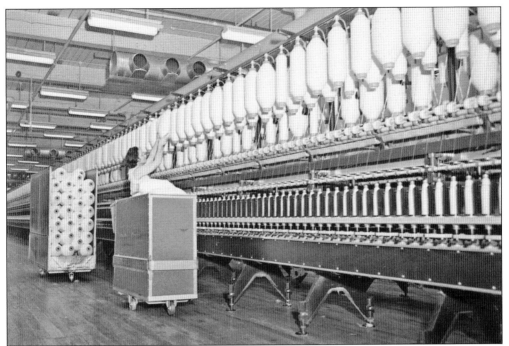

Modernization came to the mills swiftly in the mid-20th century. Large modern equipment had been installed and no longer required the large workforce of years past. In this photograph, a woman changes the spindles of a massive looming machine at a Bibb Manufacturing Company mill. (*Bibb Recorder*, Terry Webb.)

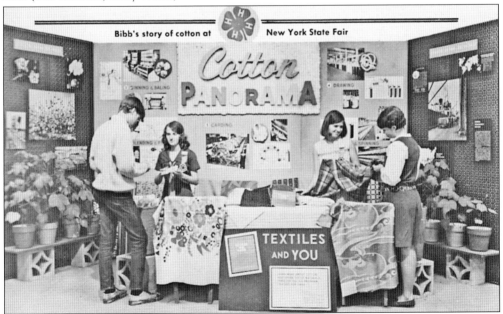

The textile mills were important industrial leaders not just in Central Georgia but also in the textile industry across America. Here, representatives from Bibb Manufacturing Company explain how textiles are made in its mills to visitors to the New York State Fair in the 1960s. (*Bibb Recorder*, Terry Webb.)

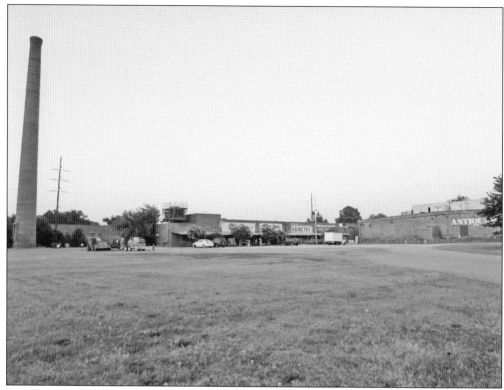

The Payne Mills are pictured here as they look today. This was once a large textile mill owned by Bibb Manufacturing Company that supported a mill village known as Payne City on the outskirts of Macon. Now the city of Macon engulfs the area around the former mill village. The remaining portion of the Payne Mills now houses an antique market and a restaurant. (Photograph by the author.)

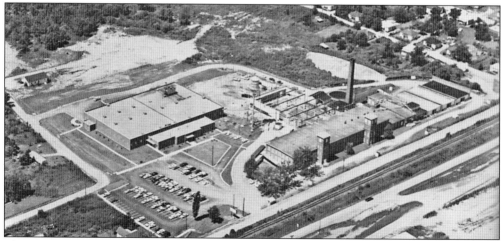

This aerial view shows the Forsyth Mill in the 1960s. The textile mill was once a large employer for Forsyth. Today the mill has been transformed into a furniture store and is a popular draw for visitors to the town. (*Bibb Recorder*, Terry Webb.)

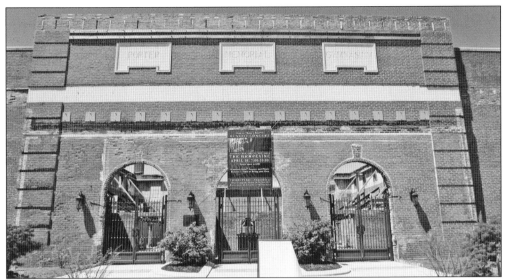

Only a shell of the Porterdale Memorial Gymnasium survives today. A 2005 fire destroyed most of the building, which was dedicated in 1938 in honor of Oliver Porter, the founder of Porterdale. The city has embraced the new open-air format of the historical structure, and it is currently used as an event venue. (Photograph by the author.)

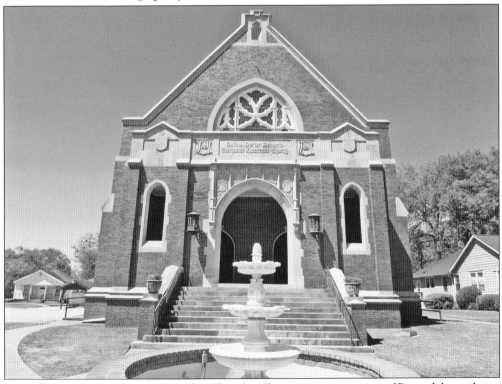

The Julia L. Porter Memorial Methodist Church still serves a congregation of Porterdale residents. The church was named in honor of the wife of the founder of Porterdale. This church, along with other pieces of the past, is still an important part of the community of Porterdale. (Photograph by the author.)

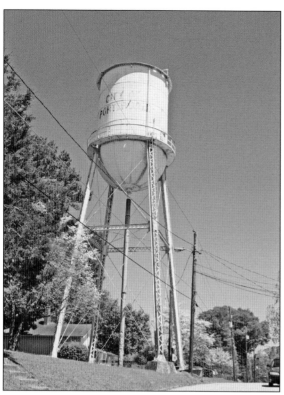

The water tower in Porterdale bears the almost-faded markings of the "City of Porterdale." Today, Porterdale is the best preserved example of a mill village in Georgia. It is a great symbol of the forgotten industrial past of Central Georgia. (Photograph by the author.)

The Porterdale Mill sits on the Yellow River. This location was chosen because of the falling waters in Central Georgia. The falling waters helped create the electricity that powered the mill. Soon the village of Porterdale grew up around the mill. (Photograph by the author.)

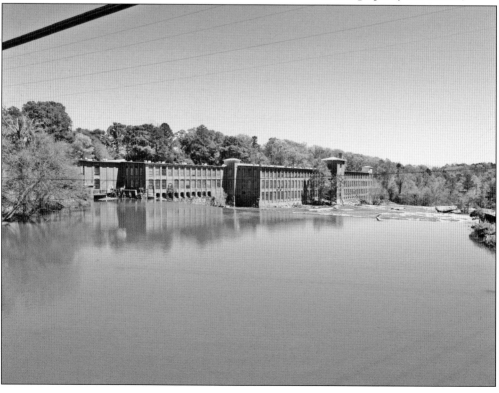

The Welaunee Hotel is a former dormitory for young women who worked at the Bibb Manufacturing Mills in Porterdale, and today it serves as a church for local residents. When unmarried women started at the mill, they stayed at the hotel until they were assigned housing by the mill or started a family. (Photograph by the author.)

This view shows the restored downtown Porterdale. Originally, shops for the residents of Porterdale textile workers lined the street, but now the shops are open for the general public. The quaintness of Porterdale attracts many visitors looking for a glimpse of what it would have been like to live in a textile mill village. (Photograph by the author.)

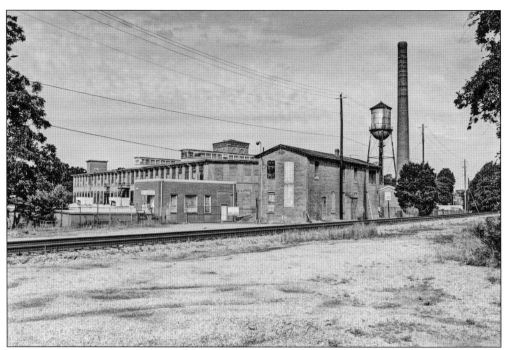

The Willingham Cotton Mill is seen as it stands today. It is the largest mill that is still mostly intact in Macon. Part of the mill has been converted into other commercial uses. It once supported a large mill village, but is now part of the surrounding neighborhoods. (Photograph by John Cook.)

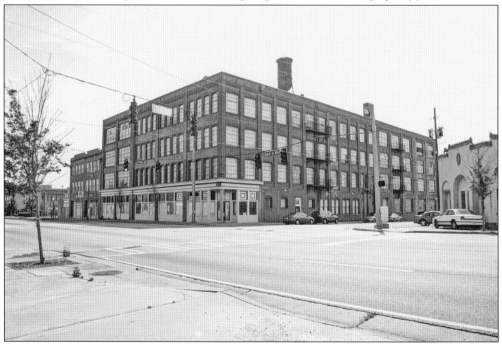

This building once housed the Happ Brothers Manufacturing Company. It has been restored and is now known as the Broadway Lofts. This company in downtown Macon was once a large employer producing clothing. The building now houses popular lofts. (Photograph by John Cook.)

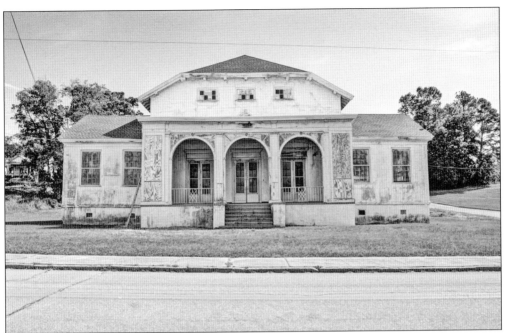

The former Bibb Mill No. 1 community center was once used by the textile workers and the residents of Bibb Mill No. 1 Village. The center is currently under restoration with the Macon Arts Alliance to create a community arts center for Macon residents. (Photograph by John Cook.)

The community center for Bibb Mill No. 2 is the only building left standing that was part of the Bibb Mill No. 2 Village. The building has been used for many different purposes over the years and currently sits unused. The former site of the Bibb Mill No. 2 is where the current Bibb County Jail is located. (Photograph by John Cook.)

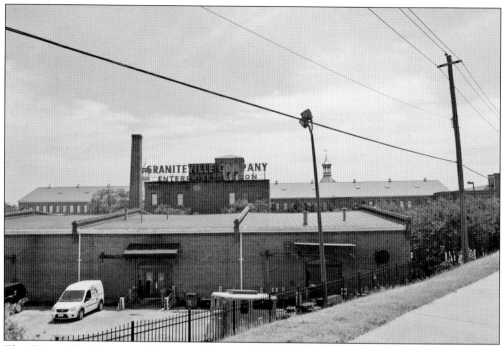

The Grantville Company–Enterprise Division Mill now houses the Augusta Canal Discovery Center as well as residential rentals. The museum inside the former mills tells the story of the textile industry and the Augusta Canal in Augusta. The hydropower generators of the mill still produce electricity for the building and all of Augusta. (Photograph by John Cook.)

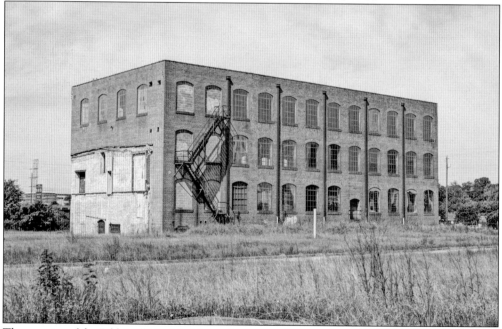

The remains of the Bibb Mill No. 1 in Macon loom over the area that once housed the massive Bibb Manufacturing headquarters. The old mill building has not been restored and sits as a reminder of the forgotten industrial history of Macon and Central Georgia. (Photograph by John Cook.)

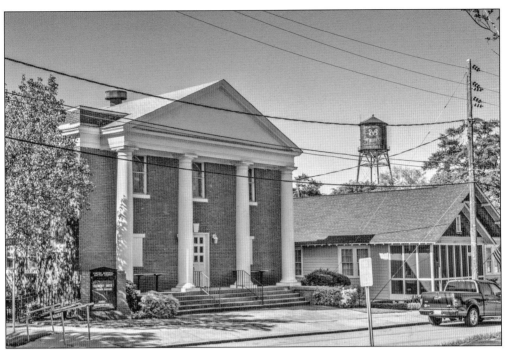

The Porter Memorial Baptist Church, located in Bibb City in Columbus, has been under the shadow of the Bibb City water tower for almost 100 years. It was originally built as a community church for the textile workers of the Bibb City Mill. (Photograph by John Cook.)

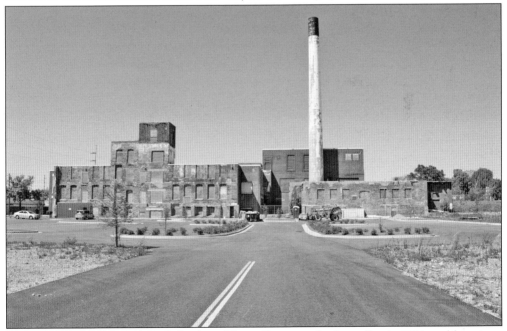

The Swift Mill is located in Columbus. The mill survived a large fire in 2011 and has since been restored, though part of the mill was destroyed. Part of the former mill buildings has been converted into lofts, while some of it has been maintained for commercial purposes. (Photograph by John Cook.)

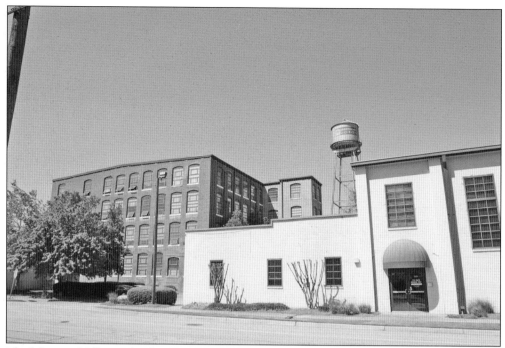

The Johnston Mill in Columbus is a former cotton mill on the Chattahoochee River that has been transformed into loft homes. The mill is adjacent to the Chattahoochee Riverwalk Park. Many mills were operated on the streets close to the river over the years. (Photograph by John Cook.)

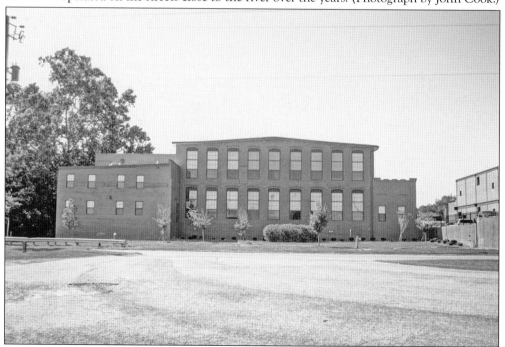

In Hawkinsville, the building for the Hawkinsville Mill has been turned into lofts that overlook the Ocmulgee River. The mill has been closed since 2001. The former warehouse for the mill now houses a flea market and event space. (Photograph by John Cook.)

The Comer Center in Bibb City was once the recreation center for the textile mill workers at the Bibb Manufacturing Mill and their families. It was restored in 2012 and is still in use as a recreation center for the residents of Bibb City. (Photograph by John Cook.)

This is a modern image of the Bibb City Elementary School. The school closed in 2001, just shy of being open 100 years. The building is now in poor shape, but the former students are trying to apply for historical preservation for the school. (Photograph by John Cook.)

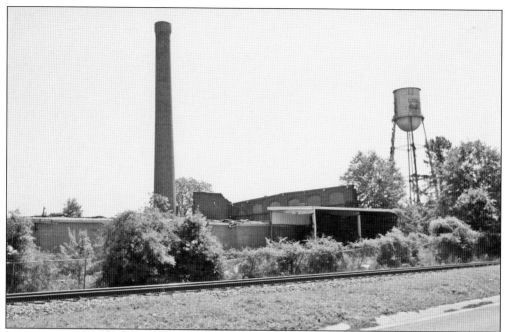

The Eastman Mills were located by the railroad tracks in Eastman for easy access to shipments of cotton and to ship out finished goods. The mill was a major employer in this small town. Today, the mill property is owned by a building supply company that operates on part of the site. (Photograph by John Cook.)

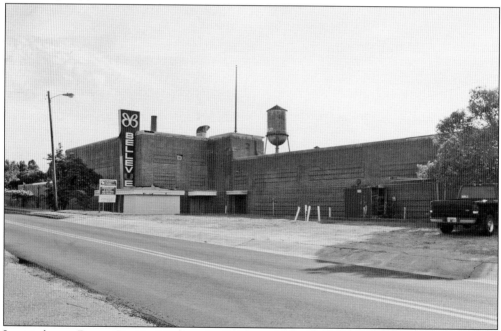

Located near Payne City in Macon, the Bellevue Mill was part of the Bibb Manufacturing Company. The mill was next to the railroad tracks for ease of shipping. The trains still come by, but the mills have been closed for many years. Currently the building is used for other commercial purposes. (Photograph by John Cook.)

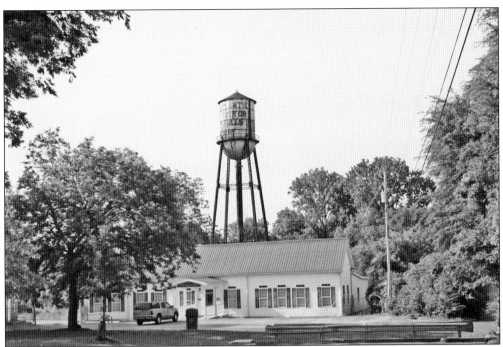

All that is left standing of the Atlantic City Mill in Macon is the water tower that still bears its name and the mill smokestack, which is not pictured. An accidental fire took place at the textile mill in 2011 while it was being renovated into loft apartments. (Photograph by John Cook.)

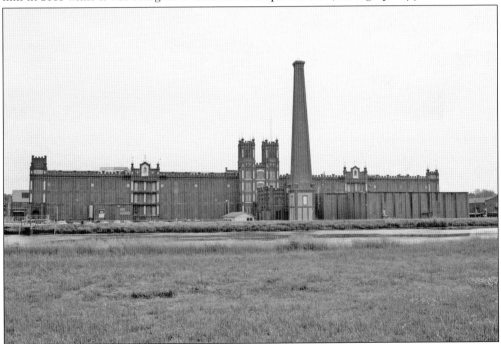

The ornate neo-Gothic architecture of the Sibley Mill still looms over the Augusta Canal. The mill no longer produces textiles, but the hydroelectric power that is generated from the canal is still used by the city of Augusta. (Photograph by John Cook.)

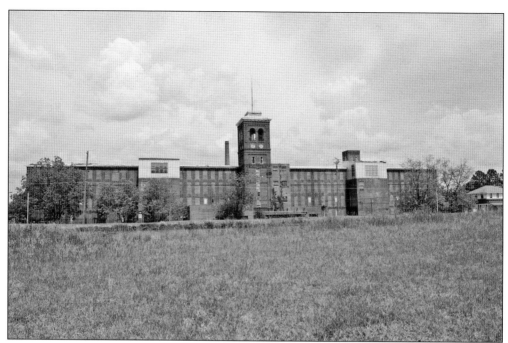

The King Mill in Augusta is located on the Augusta Canal and opened in 1881. Currently, parts of the mill are in operation with Standard Textile. The mill is located next to the Sibley Mill and was named after prominent citizen John P. King. (Photograph by John Cook.)

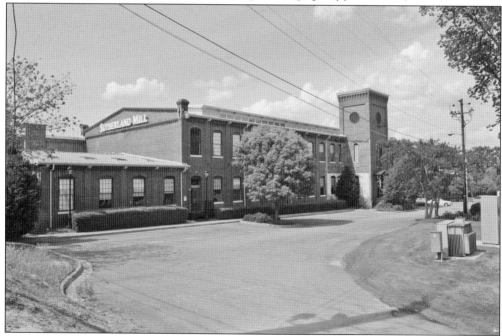

The Sutherland Mill in Augusta is located on the Augusta Canal. It is near Enterprise Mill and has been renovated and converted to commercial use. The Medical College of Georgia is located across the canal, and the mill also houses University Hospital offices. It was once known as the Dartmouth Mill. (Photograph by John Cook.)

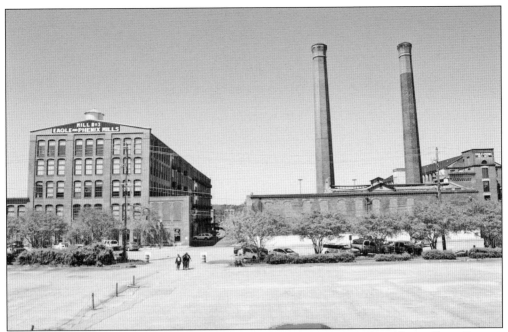

Located in downtown Columbus, the Eagle and Phenix Mill is one of the oldest mills in Georgia and operated from 1851 to 2003. This image shows Mill No. 3 and the smokestacks. Located next to the river, the mills originally made use of hydroelectricity for power. (Photograph by John Cook.)

The Taylor Mill was once part of the Bibb Manufacturing Company located just outside of Reynolds. This small mill was once called the Pottersville Mill and had a small mill village located nearby. The mill has been abandoned and sits as a reminder of the lost industrial industry. (Photograph by John Cook.)

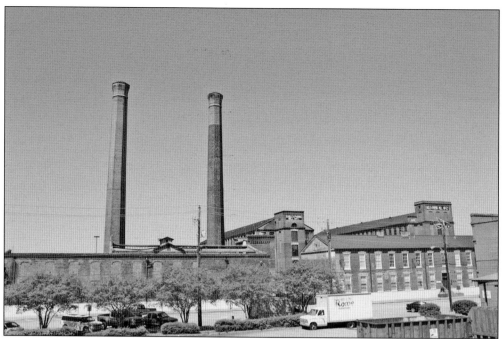

The Eagle and Phenix Mill is shown in this image on the Chattahoochee River in downtown Columbus. Mill No. 1 and Mill No. 2 are shown along with the smokestacks. The mill building is currently a mixed-use rental and commercial space. (Photograph by John Cook.)

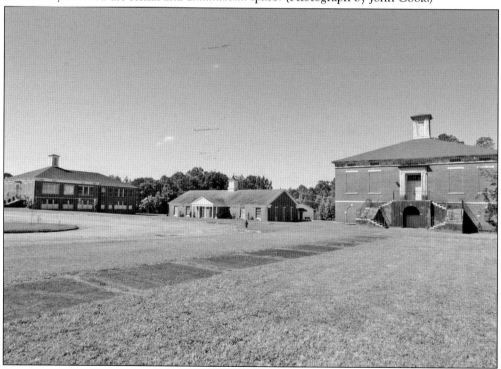

This was an elementary school built near the Thomaston Mills and the mill village of Thomaston. It would have been attended by the children of the textile workers. (Photograph by the author.)

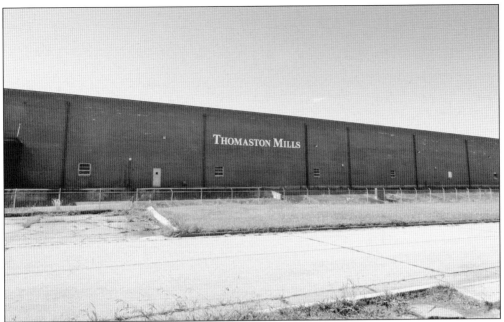

The Thomaston Mills building still stands, and textile manufacturing still takes place, but the building is no longer part of the original Thomaston Mills. The new company has acquired the Thomaston Mills trademark and is a maker of fine textiles. For many years, the mills have been the main employer in Thomaston and have driven the local economy. (Photograph by the author.)

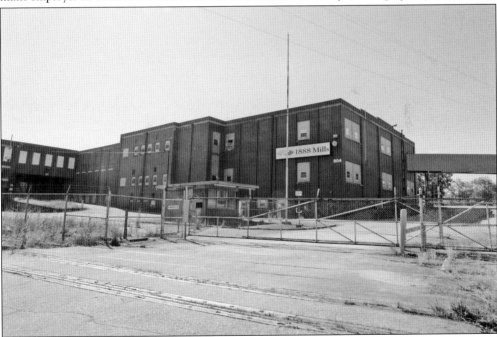

This view shows one of the older buildings of the Thomaston Mills. The mills were established in the late 1800s but have since been sold. There were multiple parts to the mills, and much of the old complex is still standing. The villages that grew up around the mills are now open to any of the residents of Thomaston. (Photograph by the author.)

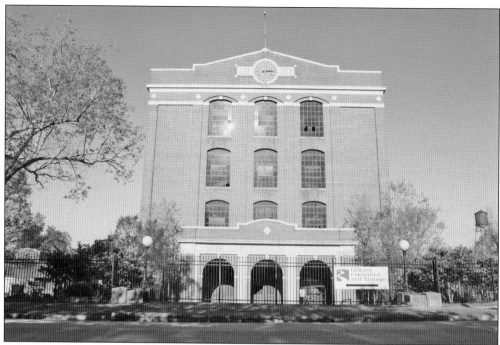

Pictured is a front view of the Bibb City Mills in Bibb City. Over the years, thousands of workers walked through these front doors on their way to work in the mills. The facade was built in 1920 along with the clock. (Photograph by John Cook.)

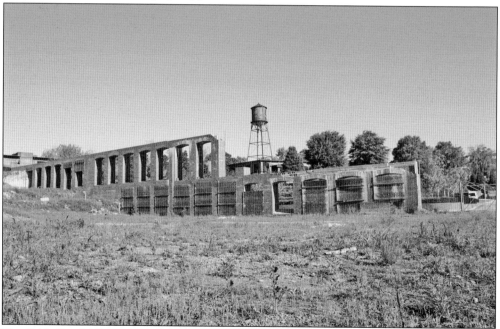

The Bibb City Mills are seen from the side. Sadly, all that is left of what was once the largest textile mill in the world is just a skeleton of a building. The mill was scheduled to be turned into a hotel and rental space, but due to a large fire in the fall of 2008, all that remains is a shell. (Photograph by John Cook.)

The Ocmulgee River and the train bridge crossing the river are pictured at sunset. The mills depended upon the rivers and railroads to transport cotton to the mills and completed textile goods to the market. (Photograph by John Cook.)

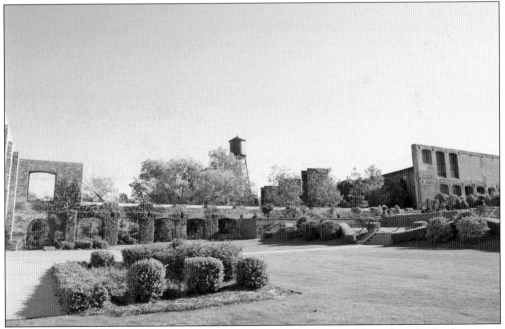

Though the Bibb City Mills in Columbus were partially destroyed by a fire, the back portion of the mills have been turned into an event venue, which is a beautiful space with views of the Chattahoochee River. Many weddings and events have taken place with the mills as a backdrop. (Photograph by John Cook.)

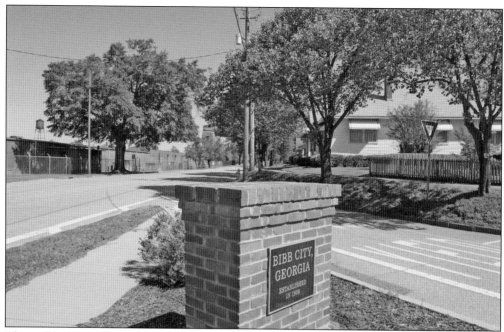

The mill houses in Bibb City grew up around the Bibb City Mills. Bibb City was established in 1909 as a mill village to support the workers of the Bibb Manufacturing Company. The houses have been renovated and are now occupied by residents of Columbus. (Photograph by John Cook.)

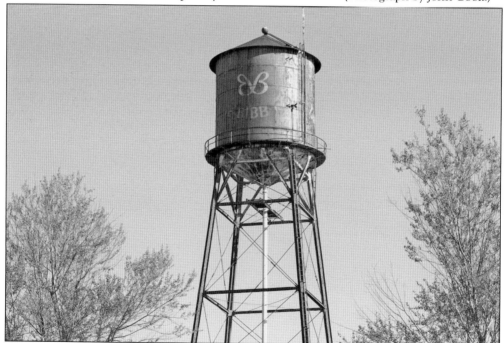

This is the water tower at Bibb City Mills, which still bears the double B trademark of the Bibb Manufacturing Company. The water tower can be seen over much of Bibb City and is a looming reminder of the past as Bibb City moves forward toward a new future. (Photograph by John Cook.)

BIBLIOGRAPHY

Andrews, Mildred Gwin. *The Men and the Mills: A History of the Southern Textile Industry.* Macon, GA: Mercer University Press, 1987.

Brattain, Michelle. *The Politics of Whiteness: Race, Workers, and Culture in the Modern South.* Athens, GA: University of Georgia Press, 2004.

Eskew, Glenn T., ed. *Labor in the Modern South.* Athens, GA: University of Georgia Press, 2001.

Hall, Jacquelyn Dowd, et al. *Like a Family: The Making of a Southern Cotton Mill World.* Chapel Hill, NC: University of North Carolina Press, 2000.

Irons, Janet. *Testing the New Deal: The General Textile Strike of 1934 in the American South.* Urbana, IL: University of Illinois Press, 2000.

Phillips, Vicki. "The Thomaston Turnaround." *Results.* (Winter 2003).

Pogue, Jan. *For One Glorious Purpose: Georgia Textiles: Our Heritage, Our Future.* Atlanta, GA: Georgia Textile Manufacturers Association, 2000.

Discover Thousands of Local History Books Featuring Millions of Vintage Images

Arcadia Publishing, the leading local history publisher in the United States, is committed to making history accessible and meaningful through publishing books that celebrate and preserve the heritage of America's people and places.

Find more books like this at
www.arcadiapublishing.com

Search for your hometown history, your old stomping grounds, and even your favorite sports team.

Consistent with our mission to preserve history on a local level, this book was printed in South Carolina on American-made paper and manufactured entirely in the United States. Products carrying the accredited Forest Stewardship Council (FSC) label are printed on 100 percent FSC-certified paper.